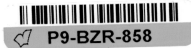

POSTCARD HISTORY SERIES

Joliet

This "Greetings from Joliet" postcard shows seven different area photographs. Located inside the letters of the word *Joliet*, the landmark images include, from left to right, St. Joseph Hospital, the administration building at Stateville prison, Brandon Road Lock and Dam, the guard tower inside a circular cell house at Stateville prison, Chicago Street looking north, and the Ruby Street bridge over the Illinois Waterway. The top photograph on the postcard shows the exterior view of two circular cell houses at Stateville.

On the front cover: Located on the northeast corner of Chicago and Van Buren Streets, the Rialto Square Theatre stands as a familiar sight in the downtown Joliet district. It opened to patrons on May 24, 1926. Thousands of entertainers have since graced the Rialto's performance stage, including Bob Hope, Lawrence Welk, and the Marx Brothers. In 1980, a $6 million restoration program began to restore the theater to its original splendor. The grand reopening took place in November 1981. (Courtesy of the Lewis University Canal and Regional History Special Collection.)

On the back cover: By the beginning of the 20th century, Joliet residents began enjoying leisure time in the many fine parks around the city. West Park, formerly known as Bush Park, was a beautiful park with wooded ravines, long winding roads and footpaths, and a variety of activities for nature lovers. This postcard photograph shows the artificial pond and footbridge located on the south side of the park. In the winter months, the pond was used for ice-skating. (Courtesy of the Joliet Public Library Special Collection.)

POSTCARD HISTORY SERIES

Joliet

David A. Belden

ARCADIA
PUBLISHING

Published by Arcadia Publishing
Charleston SC, Chicago IL, Portsmouth NH, San Francisco CA

Printed in the United States of America

Library of Congress Catalog Card Number: 2007940131

For all general information contact Arcadia Publishing at:
Telephone 843-853-2070
Fax 843-853-0044
E-mail sales@arcadiapublishing.com
For customer service and orders:
Toll-Free 1-888-313-2665

Visit us on the Internet at www.arcadiapublishing.com

CONTENTS

ACKNOWLEDGMENTS

The publication of this book would not have been possible without the assistance and support of various institutions and individuals. The area historical repositories and institutions have provided help, material, and support from their collections for this book: Lewis University, Mary Ann Atkins and John Lamb; the Joliet Public Library, Roger Gambrel and Connie Dubovsky; the Joliet Area Historical Museum, Kim Shehorn-Martin, Mary Tucci, and Heather Bigeck; the Morris Antique Emporium, Rich and Marie Badon, Conley Jacobson, and Mike Arbanas; and Minooka Community High School, Robert Williams, Kathy Krakowski, Anne Seidel, Sandy Houser, Dave DiLorenzo, Sherry Harris, and Dr. David Middleton.

Several people have also been helpful with local histories, materials, and equipment, and to the following individuals I am very grateful: Carolyn Kinsella, Kathy Friant, Les Kern, and Glenda Smith. I would also like to especially thank Roger Gambrel at the Joliet Public Library and Linda Carlson at the Joliet Area Historical Museum for their time, assistance in providing materials, and guidance on the early history of Joliet. The digitization of materials would not have been possible without the generosity of EcoLab, Joliet Plant, and Candace Schlesser. Thanks to Jen Gabel for providing her time and expertise in helping to proofread the text for this book.

The production and preparation of the material for this book would never have been possible without the dedication of numerous students in my local history classes. I wish to thank Dominic Cappellett, Stephanie Colvin, Shane Duffy, Kayle Gray, Ashleigh Kozar, Chris Riney, Deven Romines, Allison Baker, Jon Cappel, Nicholas Gates, Brett Hasler, Sean Healy, Allyn Perry, Krystal Scheidt, Nicolle Schwebel, Matthew Stewart, Dominic Williams, and Chelsea Bestow. A very special thank-you to Ashley Bishop for all her technology assistance and Brielle Shroyer for her organizational skills and postcard selections, which helped make this book possible.

Finally I acknowledge the help of John Pearson and Jeff Ruetsche at Arcadia Publishing; my wife, Krystyna, for her patience and support while I worked on this book; and for my late grandmother Mary, who sparked my early interest in history all those many years ago.

INTRODUCTION

People of every place and in every time deserve a history. Only local history satisfies the need to remember the most routine matters and the most intimate parts of our lives. Local history allows us to reconstruct the everyday lives of those who lived before us: their goods, their machines, the tools with which they worked, and the groups of which they were a part within their communities. Local history helps us all recapture how they experienced the world in which they lived and how we can better understand them. Every community has stories to tell, and let these postcards invigorate one's desire to research the local history of his or her community.

Deltiology, the term used for the collection and study of postcards, is thought by many to be one of the largest collectable hobbies in the world. In fact, no hobby compares with collecting postcards in the way that it caters to everyone's unique interests. The origins of this hobby are linked with the most interesting consumption phenomena at the beginning of the 20th century—the craze for the picture postcard. Beginning between 1895 and 1900 and fading out between 1915 and 1920, these two decades, often called the golden age of the picture postcard, changed the way people communicated. The desire for postcards seized both young and old, males and females, in the United States and in Europe, and on other continents as well. Except for the mania for the postage stamp, there had never been up to that time a more ubiquitous fad for a material item.

But it was not only the imagery, or the card as a picture carrier, that mattered to the public. The postcard as a physical object had two sides. The exchange and gift economy of the postcard also included the inscriptions of the sender to the addressee. Although the cards carried messages more or less void of information, they did serve as a sign of life and a reminder of the social relationships that existed in a certain place in time. Whether the postcard contains a short inscription, a delicate message, a signature, a set of initials, or an interesting address, each is a snapshot of the past: a moment, a part of social history, frozen in time. These postcards were exchanged between people who knew one another and for whom the context was known. No card is totally void of useful information; the picture, stamp, postmark, message, and address are all part of the life of two people in the past.

The United States Postal Service issued prestamped postal cards in 1873. The postal service was the only one allowed to print such cards until 1898, when Congress passed the Private Mailing Card Act, which allowed private companies to produce and sell cards. Postcards printed and sold before 1898 are generally considered to be part of the pioneer era. Postcards produced from 1898 to 1901 are considered part of the private-mailing-card period. The five distinct periods of postcard history since its rise in popularity in the early 20th century include

the undivided-back era (1901–1907), when messages were only permitted on the front of the card and the back was designated for the recipient's name and address; the divided-back era (1907–1915), when the back of the card had a designated area for a message and the mailing address; the white-border era (1915–1930), when American postcard printers began filling the void left by the European publishing industry and to save money and ink, because of the higher postwar publishing costs, many publishing firms left white borders around the edges of the postcards; the linen era (1930–1944), when the majority of postcards were produced on a linen stock and significant improvements in color quality occurred; and the photochrome era (1939–present), when postcards began to be easily produced, of high photograph quality, and, most importantly, were in glossy color.

Joliet is an Illinois city that lies about 45 miles from Chicago on the southwest edge of the Chicago metropolitan area. Situated on the banks of the Des Plaines River, Joliet is the county seat of Will County. Founded in 1673 by French Canadian explorers Louis Jolliet and Fr. Jacques Marquette, the site of the present-day city of Joliet was not organized as a town until 1834, when James B. Campbell, treasurer of the canal commissioners, arrived and laid out the village of Juliet, a name that many local settlers had been using. Charles Reed built a cabin along the west side of the Des Plaines River in 1833 and is considered by many historians to be the first settler in the area. Juliet was part of Cook County until 1836, at which time it became the county seat of the newly established Will County. In 1845, the community's name was changed to Joliet, and in 1852, Joliet was reincorporated as a city.

The local quarrying of limestone earned Joliet the nickname "City of Stone," and the contractors who built the Illinois and Michigan Canal used the local stone in the building of locks, bridges, and aqueducts along the route. After the canal opened in 1848, the canal became an artery for shipping stone to other regional consumers. Joliet stone was used to build the new Illinois State Penitentiary in 1858 north of the town, and the Chicago Fire of 1871 spurred demand for stone for new construction in the region. It was during this time that Joliet also emerged as the "City of Steel," with the construction of its first mill in 1869. The steel mills in Joliet attracted thousands of southeastern Europeans, who came to the city in search of employment. The city's large labor force and its steel mills attracted many other industries, including stove companies, wire mills, horseshoe factories, brick companies, boiler and tank companies, machine manufacturers, can companies, plating factories, bridge builders, and foundries. Over time, other industries have called Joliet home, including greeting cards, calendars, bottling, brewery, wallpaper, pianos, automobile, oil, and chemical products. Joliet's economy entered a period of decline in the late 1970s, and unemployment was a major problem in the area during the 1980s. During the 1990s, Joliet's economy rebounded, and tourism became an important industry, aided by the establishment of riverboat casinos, and the infusion of new tax dollars fueled a revitalization of the downtown city center.

The postcards selected for this publication represent the five distinct periods outlined above. Of particular interest as this postcard project was digitized were the written messages found on both sides of the card. While the postcard cannot serve as a medium for substantial messages, it does open a window to how people thought and communicated in the past. Longer, more intimate messages still had to be sent by ordinary closed letters, but by the early part of the 20th century, the picture postcard became the perfect medium for short communications. When appropriate, an attempt has been made to include the correspondences found on the postcards in this collection.

"No place is a place until the things that happened in it are remembered in history, yarns, legends, or monuments," wrote Wallace Stegner in *Where the Bluebird Sings to the Lemonade Springs*. Postcards are one piece to help remember a place or what happened in the past. It is important for us to remember that all history is local and every place is a universe unto itself.

One

STREETSCAPES

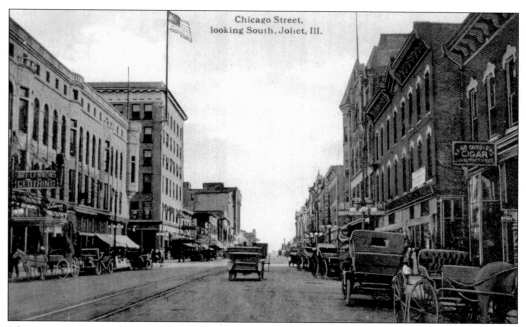

This postcard is a photograph of Chicago Street looking south near Cass Street. The long limestone building on the left is the auditorium building, which housed the city's first civic auditorium and functioned throughout the years as a cultural arts center for the community. Farther down the block, the six-floor building flying the American flag was home to Ford Hopkins Drugs and Lewis Brothers' Shoes. Across the street, the Joliet Opera House, with its cone-shaped tower, can be seen.

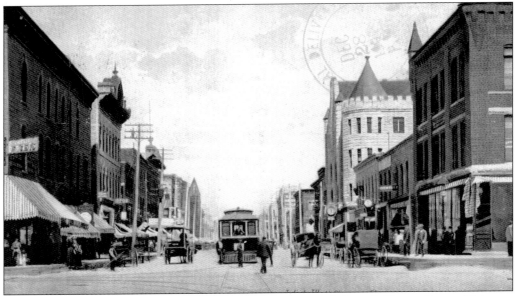

This postcard shows a view of Chicago Street looking north from Jefferson Street. This was considered an important shopping district for people coming by streetcar or horse-drawn carriage, and the postcard shows the wooden electrical poles on both sides of the unpaved street. The building on the northeast corner of Chicago Street is the Harris and Foley Store. Across the street on the northwest corner is the very popular Blacy's candy and ice-cream shop.

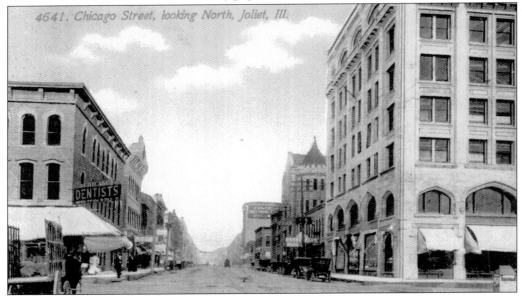

The seven-story neo-Gothic structure on the northeast corner, designed by Sullivan and Marshall, was originally known as the Woodruff Building when it was constructed in 1910. It was later renamed the Morris Building in 1934. Farther down the block on the east side of the street are the Barber Building and the First National Bank building. The building on the northwest corner is the Goodspeed Building, home to the Chicago Dentists and the Blacy and Company Confectioners.

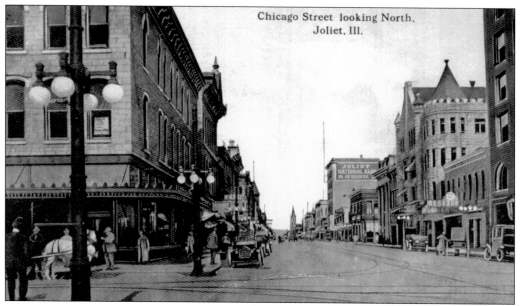

Chicago Street looking North,
Joliet, Ill.

This postcard from the early 20th century shows the familiar corner of Chicago and Jefferson Streets looking north. The building on the left is the Goodspeed Building, and just down the block on the west side of Chicago Street is the Munroe Block building. Across the street, the familiar limestone structures of the Woodruff and Barber Buildings can be seen in the foreground, and the Corinthian columns of the First National Bank can be seen down the block.

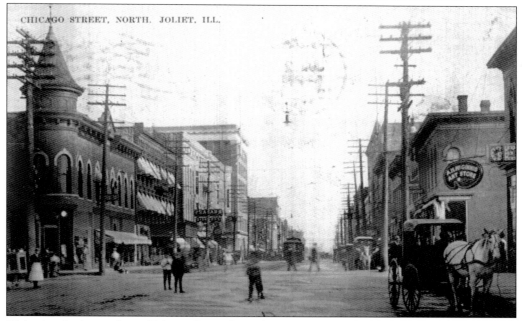

CHICAGO STREET, NORTH. JOLIET, ILL.

This view looks south on Chicago Street from the intersection of Cass Street around 1909. The horse and buggy on the right is parked in front of the Gem Theatre and the A. H. McGinnis Art Store. Across the street on the west side is the Mahoney Grocery Store. Directly across Chicago Street, the cone-shaped spire of the Murray Building is visible.

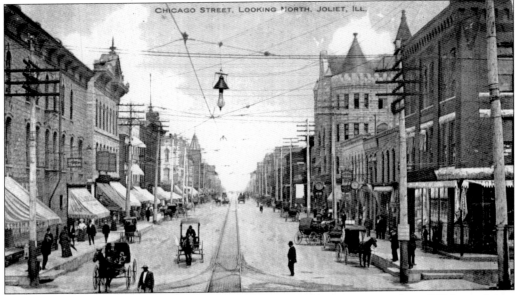

This early-20th-century postcard photograph shows the familiar intersection of Chicago Street looking north from Jefferson Street. The streetcar tracks in the middle of the street, horse-drawn buggies, and overhead electric wires supported by wooden poles show life in an earlier time. The Harris and Foley Store and the Barber Building can be seen on the east side of the street, and the Goodspeed Building and Munroe Block building are visible on the west side of the block.

636—NORTH CHICAGO STREET, JOLIET, ILL.

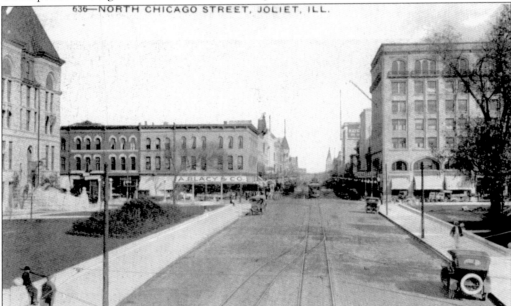

This postcard shows a photograph of Chicago Street near the intersection with Jefferson Street. The third Will County Courthouse, designed by John C. Cochrane and built in 1884–1887, can be seen on the left. Across the street, the storefront awning of Blacy and Company Confectioners in the Goodspeed Building can be seen in the distance. The seven-story Morris Building is directly across the street.

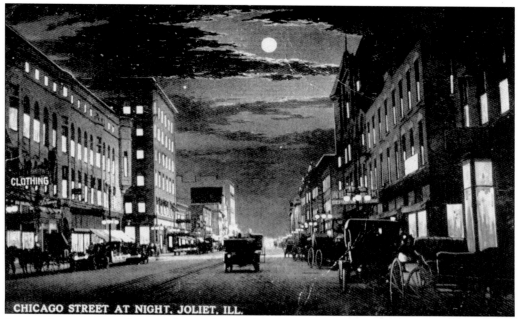

CHICAGO STREET AT NIGHT, JOLIET, ILL.

Postcard companies often used artistic measures to augment photographs to create unique scenes. In this postcard, an artist created a nighttime scene of Chicago Street looking south near Cass Street. A full moon was also added to make the look even more picturesque. The long limestone building on the east side of the street is the auditorium building, and across the street, on the northwest corner of Chicago and Clinton Streets, sits the Joliet Opera House, with its cone-shaped spire and flagpole.

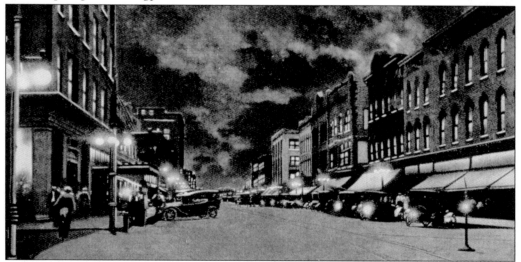

The subject of this postcard is Chicago Street at night looking south from Clinton Street. During the 20th century, many businesses operated storefronts along the west side of the street, including Ducker's Corner Store, F. W. Woolworth's, S. S. Kresge's, and Osco Drug. Along the east side of Chicago Street are the Woodruff Building, the First National Bank, and the Princess Theatre. By 1926, the familiar Rialto Square sign would be visible on the northeast corner of Van Buren and Chicago Streets.

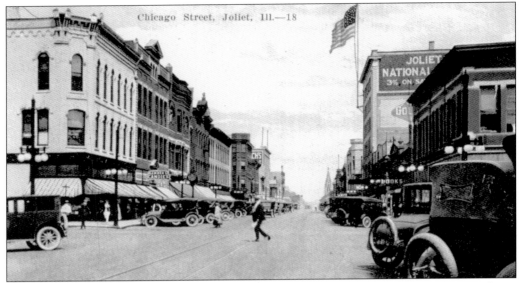

This postcard is a photograph of Chicago Street looking north from the intersection of Van Buren Street. Just outside the camera view on the southeast corner of Van Buren and Chicago Streets is the First National Bank. The two-story building across the street was eventually razed to make room for the new Rialto Square Theatre in 1926. Farther down the block on the east side of the street, the six-floor building flying the American flag is home to Ford Hopkins Drugs and Lewis Brothers' Shoes.

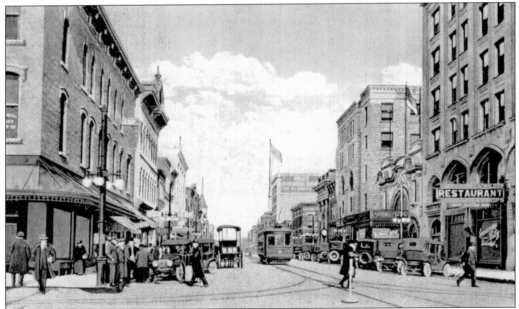

This postcard photograph shows north Chicago Street from the intersection at Jefferson Street. On the west side of the street, beginning at the corner, is the Goodspeed Building, followed by the Munroe Block (1878). Across the street on the east side of the block is the Woodruff/Morris Building (1910), with the Schneiter's Restaurant sign in the foreground, followed by the Princess Theatre and the Barber Building (1887).

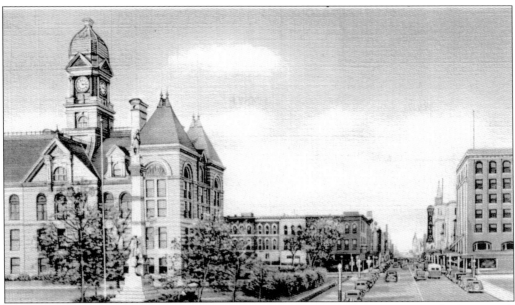

This linen-era postcard from the 1930s shows the familiar scene of Chicago Street looking north toward Jefferson Street. The prominent third Will County Courthouse can be seen on the left, with the Civil War memorial towering in the foreground. Familiar buildings in the background include the old seven-story Bedford limestone structure known for many years as the Woodruff Building. Across the street on the opposite corner sits the old Goodspeed Building.

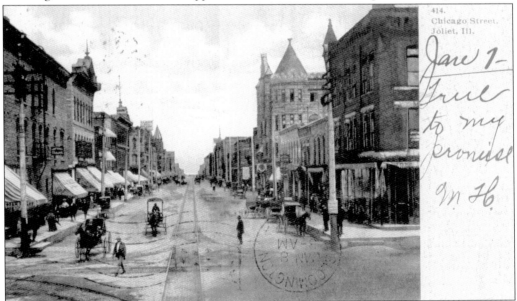

This undivided-back postcard by Curt Teich and Company uses an early-20th-century photograph that shows the familiar intersection of Chicago Street looking north from Jefferson Street. Notice that overhead electric wires have been brushed out of this photograph, but the wooden poles still remain on the street corners. Because the back of the postcard is only for the address, the postcard company gives the sender space on the right for a short correspondence.

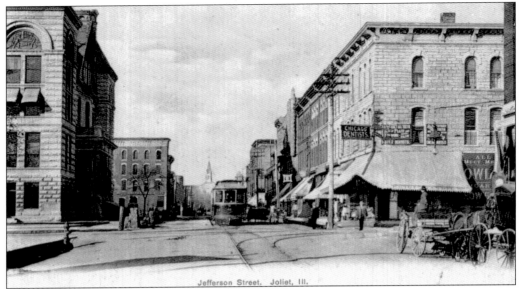

Jefferson Street. Joliet, Ill.

This early undivided-back postcard features a picture of Jefferson Street looking west from Chicago Street. The Goodspeed Building is on the right with the advertising sign for the Chicago Dentists displayed on the corner. In the middle of the block, the corner pillar of the Cutting Building is visible. On the south side of the block, the third Will County Courthouse, designed by architect John C. Cochrane of Chicago, can be seen. The four-story building west of the courthouse is the old Will County National Bank building.

This modern photochrome-style (Curteichcolor) postcard is a photograph of Chicago Street near the intersection with Jefferson Street in the early 1950s. The third Will County Courthouse can still be seen on the left through the trees. Across the street at the corner of Jefferson and Chicago, the three-story Goodspeed Building can be seen. The seven-story Morris Building is across the street on the northeast corner of Chicago and Jefferson. The famous Rialto Square Theatre is in the distance.

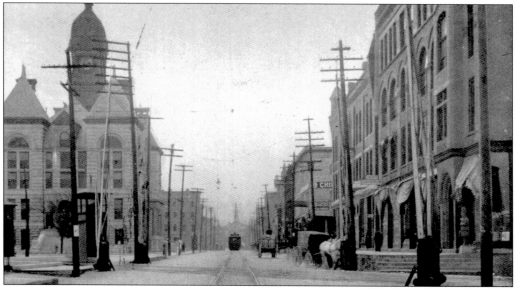

A careful look at this postcard reveals the various modes of transportation available in Joliet at the beginning of the 20th century. A streetcar in the center of Jefferson Street is heading east toward the courthouse. A horse-drawn buggy is parked in front of the Young Building, and another is heading west near the Goodspeed Building. The tracks of the Chicago, Rock Island and Pacific Railroad can been seen in the foreground, passing diagonally across Jefferson and through the courthouse square.

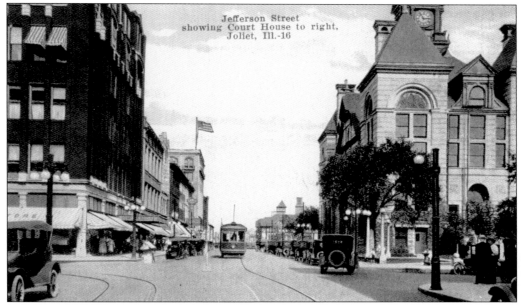

A view of the intersection of Jefferson Street looking east from Ottawa Street is the subject of this postcard photograph. In the foreground on the right is the third Will County Courthouse. Farther down the block in the background, the Woodruff Inn is visible. Across from the courthouse on the northeast corner of Ottawa and Jefferson Streets is the Boston Store, one of Joliet's noteworthy retailers.

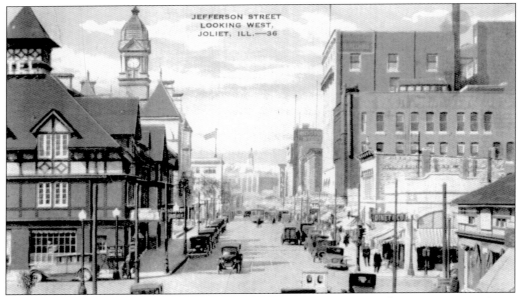

Looking west on Jefferson Street from the intersection of Scott Street, the two most prominent buildings on the south side of the street are the Woodruff Inn, in the foreground, and the Will County Courthouse. The Woodruff Inn opened for business in late 1915 and had distinctive old-English-style architecture that made it stand out in the downtown cityscape. The Young Building, Woodruff Building, and Boston Store are the tall structures on the north side of the street.

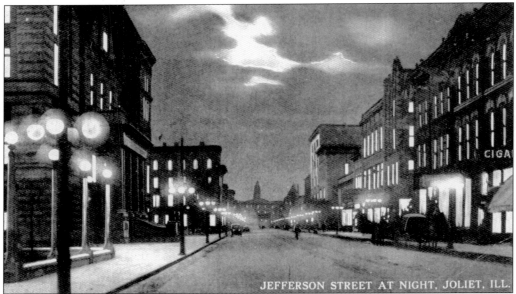

In this postcard, an artist created a full moon scene of Jefferson Street looking west near the intersection at Chicago Street. The building to the left in the foreground is the Will County Courthouse. In the distance, the illuminated old Will County National Bank building, at the corner of Jefferson and Ottawa Streets, is clear. The buildings on the north side of street include the Goodspeed and Cutting Buildings.

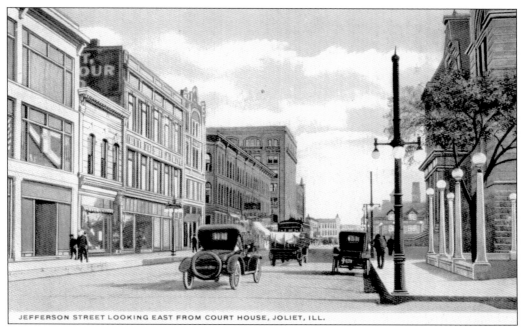

JEFFERSON STREET LOOKING EAST FROM COURT HOUSE, JOLIET, ILL.

Looking east on Jefferson Street from Ottawa Street, two downtown landmarks are visible on the south side of the street: the third Will County Courthouse on the right and the Woodruff Inn in the distance. The seven-story Woodruff (Morris) Building can be seen on the northeast corner of Chicago Street, and the long three-story Goodspeed Building is directly across the street. The narrow Cutting Building, built from Bedford limestone, is on the north side of Jefferson, across the street from the courthouse.

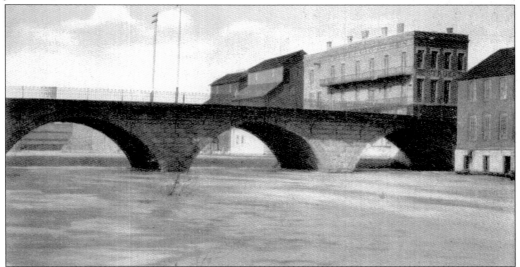

The stone arch bridge at Jefferson Street was built in 1871 and joined the east and west sides of the town. Looking north up the Des Plaines River, this view shows the old Jefferson Street bridge and dam around 1890. The building on the right in the foreground housed Joel A. Matteson's woolen mill and store. Just south of the bridge and out of view to the left was the Illinois and Michigan Canal and lock tender's house.

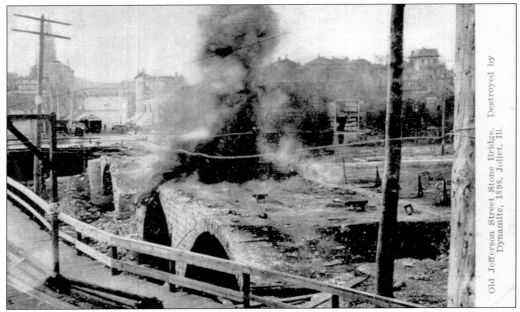

This divided-back postcard photograph shows the old Jefferson Street stone bridge being destroyed by dynamite in 1898. The stone arch bridge, which connected Jefferson Street on the east side with Exchange Street on the west, spanned the Des Plaines River for nearly 30 years. The guardrail of the temporary bridge can be seen in the foreground. The sign across the river on the left is an advertisement for J. C. Adler's market.

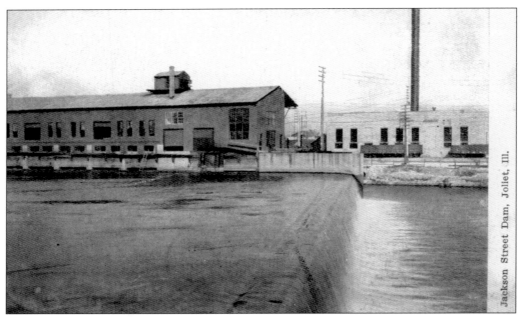

Looking east across the Des Plaines River, this view shows the Jackson Street dam in the foreground and the powerhouse plant of the Economy Light and Power Company, formed in 1890, on the left. The dam helped to operate the large generators that supplied the power to the city.

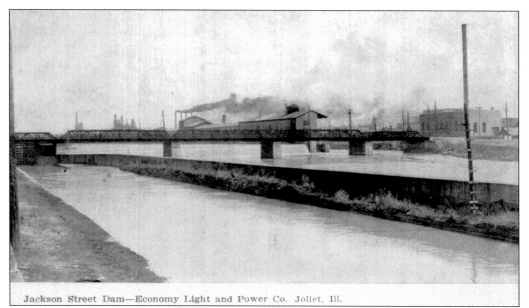

Jackson Street Dam—Economy Light and Power Co. Joliet, Ill.

Looking west across the Des Plaines River, the Jackson Street bridge and dam can be seen. This postcard photograph was taken from the Economy Light and Power Company on the east side of the river. The old Jackson Street bridge, the dam, and the Illinois and Michigan Canal were cleared and removed in 1932 as part of the deepwater Illinois Waterway Project.

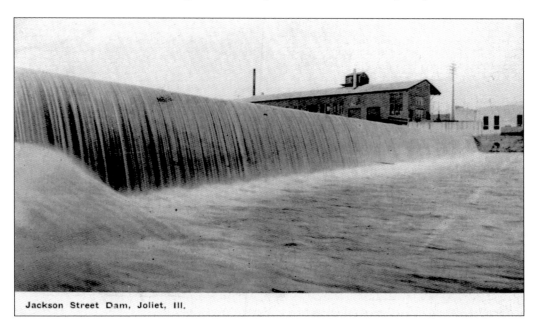

Jackson Street Dam, Joliet, Ill.

This divided-back postcard shows the Jackson Street dam and Economy Light and Power Company plant. Looking east across the Des Plaines River, this postcard shows part of the raceway and dam that carried water from the Des Plaines River to help produce power to operate the electric plant. The power needed to run the company generators was created by the 12-foot drop in water level from the upstream headrace to the downstream tailrace.

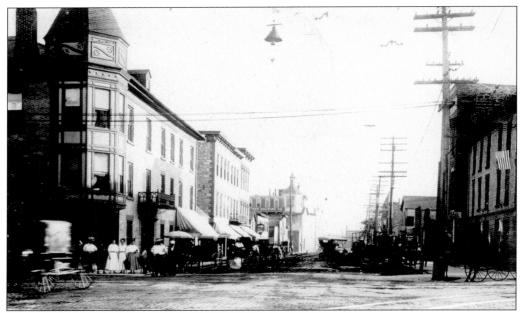

This early postcard photograph shows Bluff Street looking south from Exchange (Jefferson) Street. The National Hotel, with its cone-shaped rooftop spire, and J. C. Adler Company Meat Market occupy the building in the foreground on the left. Farther down the block on the east side are Theiler Brothers Grocers and Saloon and the E. Porter Brewing Company.

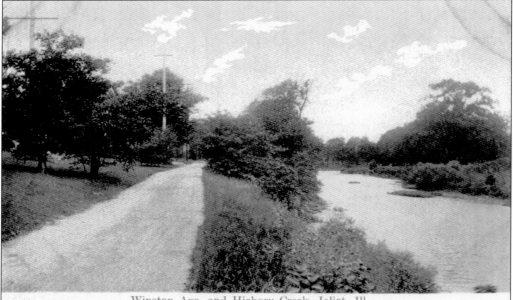

Winston Ave. and Hickory Creek, Joliet, Ill.

Located on the east side of Joliet, Winston Avenue is a small street that runs parallel to Hickory Creek from East Fourth Avenue to Elmwood Avenue. Hickory Creek flows southwestward for nearly 21 miles, feeding into the Des Plaines River at Joliet. The creek flows through many of Will County's beautiful parks, including Higginbotham Woods, Pilcher Park, and the Hickory Creek Preserve.

Western Avenue has become one of the most desirable areas for vintage homes of beautiful architecture dating back to the late 1800s. This postcard shows the 600 block of Western Avenue looking west from Clement Street. The house on the right, at 607 Western, is an example of the popular Queen Anne–style home. Down the block on the right, the Frederick Arentz house, at 611 Western, is an example of the neoclassical style.

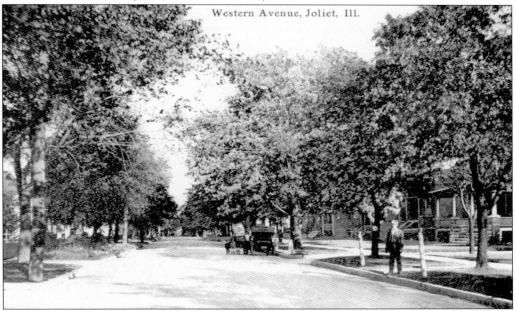

Western Avenue, Joliet, Ill.

Western Avenue is an east–west arterial street that links the area to Joliet's downtown city center via the Cass Street bridge. Just west of the Upper Bluff Local Historic District is Joliet's Cathedral Area, which is one of the most desirable areas for vintage homes of beautiful architecture and history. This postcard shows the 800 block of Western Avenue looking east toward Raynor Avenue.

The greatest period of growth for the Upper Bluff Local Historic District and Joliet's Cathedral Area occurred during the period from 1880 to 1920. This postcard photograph shows a view of the historic district from the corner of Buell Avenue and Nicholson Street. The large Queen Anne–style home, located at 429 Buell Street, can be seen in the distance. The home, constructed around 1885, was once owned by prominent businessman and mayor of Joliet Sebastian Lagger.

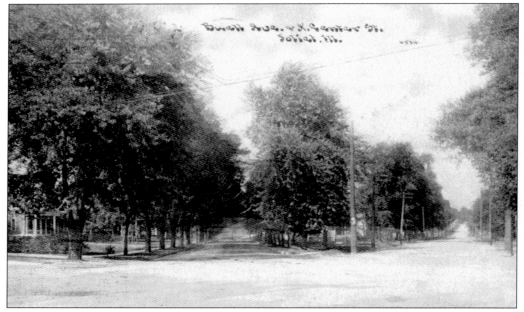

Center Street on Joliet's west side divides the Upper Bluff Local Historic District to the east from the Cathedral Area to the west. This divided-back postcard shows a northern view from the busy intersection of Center Street and Buell and Western Avenues. The east–west street in the foreground is Western Avenue, Center Street looking north is the road on the right, and Buell Avenue is the street in the center of the photograph.

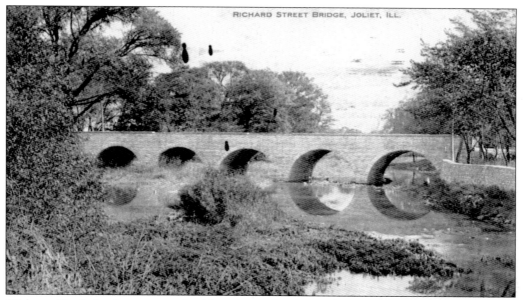

Hickory Creek has been recognized by many scientists as the gem of the Des Plaines River system. Hickory Creek flows southwestward for nearly 21 miles, feeding into the Des Plaines River at Joliet. This postcard photograph shows the old Richard Street stone bridge that crossed over Hickory Creek on Joliet's east side. The stone bridge was replaced in 1930, and remnants can be seen today just west of the current Richard Street bridge.

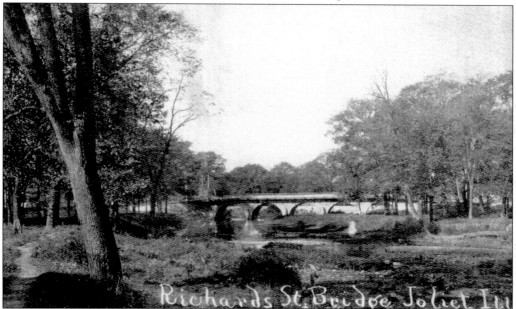

This early undivided-back postcard shows a photograph of Hickory Creek as it flows west through the east side of Joliet. In the distance, the old Richard Street stone bridge that crossed over Hickory Creek can be seen. The old arch bridge was rebuilt in 1930 by the State of Illinois and Will County. Remnants of the 1930 bridge that still crosses Hickory Creek can be seen today near Sherman Street and Fifth Avenue, just west of today's Richard Street bridge.

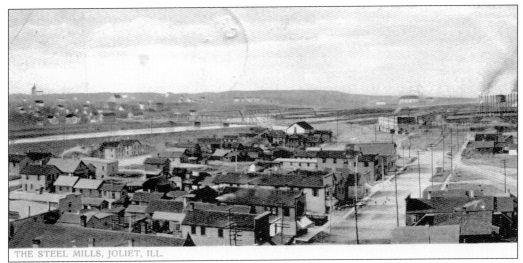

THE STEEL MILLS, JOLIET, ILL.

Looking north near the corner of Scott and Columbia Streets, this bird's-eye view shows the neighborhood near the Joliet steel mills. The Ruby Street bridge crossing the Des Plaines River can be seen in the background. Joliet is known as the "City of Steel" because the town was a major steel-producing center for many years. In the early 1870s, the Joliet Iron and Steel Company was producing iron and steel products.

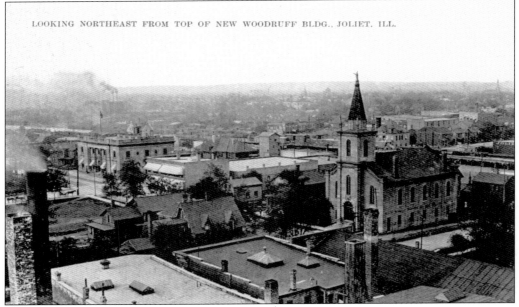

LOOKING NORTHEAST FROM TOP OF NEW WOODRUFF BLDG., JOLIET, ILL.

This rooftop view of downtown Joliet looking northeast was taken from the top of the new Woodruff Building, located at the corner of Jefferson and Chicago Streets. To the right on the northeast corner of Scott and Van Buren Streets is St. Anthon's Catholic Church, built in 1852. To the left, the U.S. post office, constructed in 1903, is visible on the northeast corner of Scott and Clinton Streets.

Two

BUILDINGS

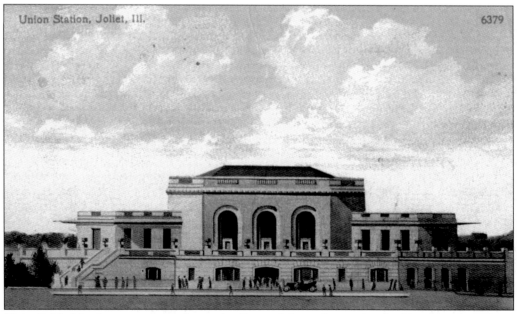

Union Station, Joliet, Ill. 6379

This divided back–era postcard shows the front of the union station looking east from Scott Street. Built in 1912 by Adam Groth and Company for nearly $250,000, the union station, with its neoclassical design, has served the city of Joliet for nearly a century. Stairs on either end of the station allow access to the elevated level of the newly designed tracks. In 1991, that station was completely renovated as part of the city center revitalization program.

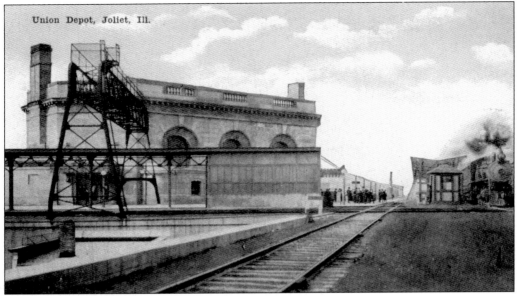

Union Depot, Joliet, Ill.

Open in 1912, the union station located at Jefferson and Scott Streets was the railroad depot for passengers taking the Rock Island Railroad to and from Joliet. This postcard photograph shows the station and the elevated tracks looking north toward Jefferson Street. The three arched windows located on the back side of the smooth Bedford limestone station can be seen on the left.

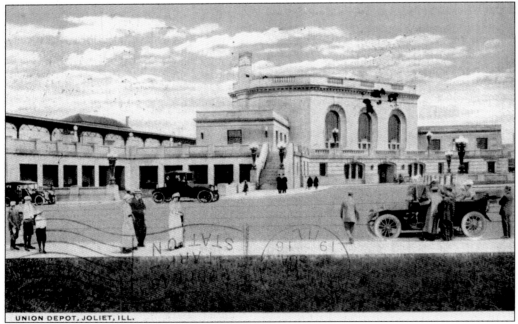

UNION DEPOT, JOLIET, ILL.

The idea for a new union station was not part of the original elevation project, but the railroad companies developed the station plan, and on May 25, 1908, the ground was broken for the station, which then advanced toward completion in conjunction with the elevation project. Built of smooth Bedford stone, the station was built by Adam Groth and Company at a cost of $250,000.

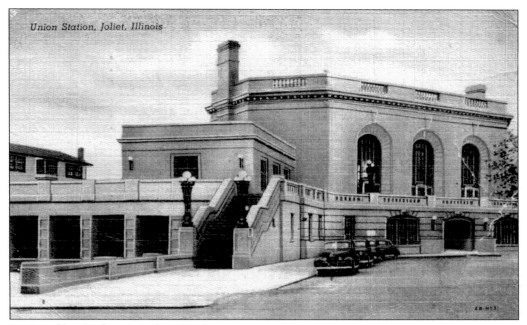

Union Station, Joliet, Illinois

Designed by the famous railroad architect Jarvis Hunt and built by Adam Groth and Company, the union station has served the residents of Joliet for nearly 100 years. The building of the station was done in tandem with the track elevation project and was complete by 1912. This postcard photograph shows the station looking south from Jefferson Street. The stairs in the foreground allowed passengers to ascend 20 feet to the track level.

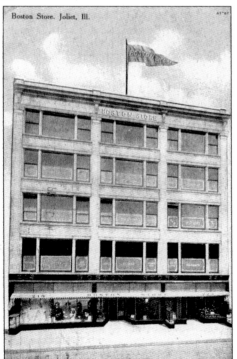

Boston Store. Joliet, Ill.

The five-story Boston Store was located just west of the L. A. Raub Clothing Store on the southwest corner of Jefferson and Ottawa Streets. The store was founded in 1889 by M. A. Felman, with an initial investment of $200. On April 26, 1908, the building was destroyed by fire as thousands watched firefighters battle the blaze. In 1917, a larger building was constructed by Felman on the northeast corner of Jefferson and Ottawa Streets, the same location as the old Spot Cash store.

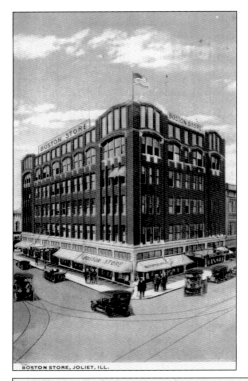

Originally located on Jefferson Street, the Boston Store was Joliet's largest department store. Early on Sunday morning, April 26, 1908, the department store was totally destroyed by fire. Arson was suspected in the blaze, which broke out on the second floor. The Boston Store eventually bought the Spot Cash grocery store lot on the northeast corner of Jefferson and Ottawa Streets and built a new building and remained in business for many years.

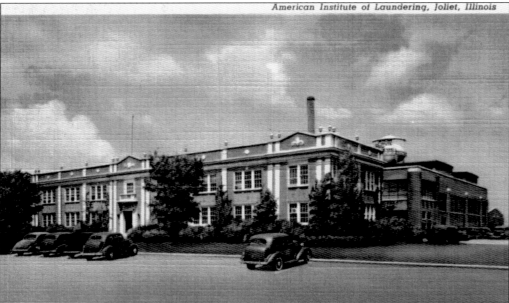

Located on the corner of South Chicago Street (Route 53) and Doris Avenue, the American Institute of Laundering operated for nearly 50 years as the international headquarters for the laundry institute, a trade association for the cleaning industry. Built in 1929, the facility employed as many as 200 people who were involved in the testing of new cleaning procedures and in management classes. The institute vacated the building in 1979.

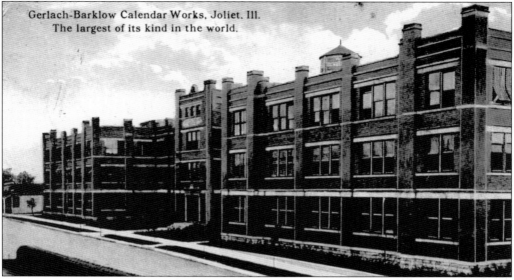

Gerlach-Barklow Calendar Works, Joliet. Ill.
The largest of its kind in the world.

The Gerlach-Barklow Company was established in June 1907, and within a month, ground was broken for the company plant on East Washington Street, just east of Richards Street. The facility manufactured calendars, postcards, greeting cards, booklets, fans, and other advertising items. By the 1950s, the Gerlach-Barklow Company was among Joliet's largest employers with more than 1,000 employees. By the 1960s, the company had merged, and the Joliet plant was acquired by the Rust Craft Greeting Card Company.

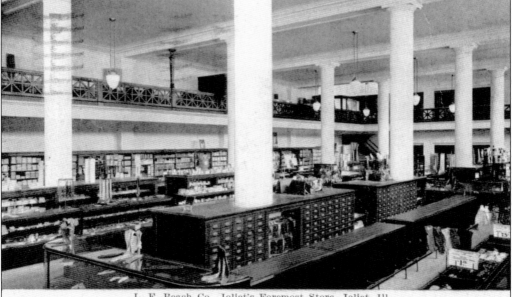

L. F. Beach Co., Joliet's Foremost Store, Joliet, Ill.

During World War I, the L. F. Beach Company bought the property on the southwest corner of Chicago and Cass Streets, the same location that Jerry Mahoney operated his grocery store for many years, and built a five-story building and operated its department store from that corner location. This photograph shows a view of the first floor and mezzanine level. Over the years, other department stores moved into the location, including Goldblatt's and Kline's.

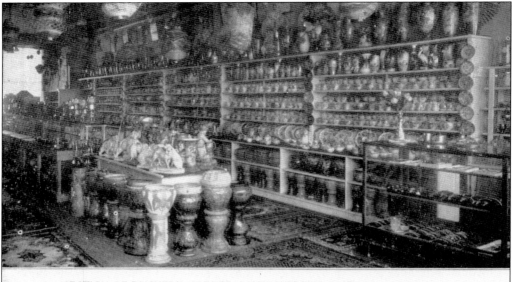

SECTION OF DUCKER'S CORNER COUPON PREMIUM STORE, JOLIET, ILL.

Ducker's Corner Store moved to the southwest corner of Chicago and Clinton Streets in 1874. The retail store sold such items as dry goods, clothing, linens, boots, shoes, carpets, silks, laces, ribbons, groceries, and much more. In large block letters on the side of the building facing Clinton Street, it claimed to be the "Retailers of Everything." This picture postcard shows an inside view of a section of the store.

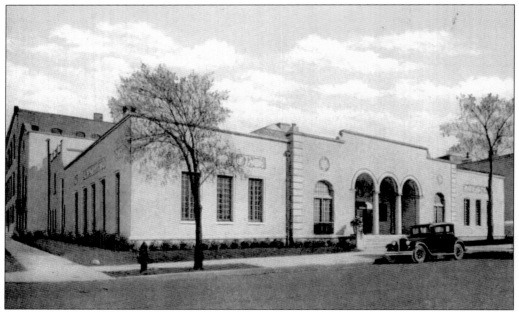

Built in 1925 for the Joliet Chamber of Commerce, the building located at 214 North Ottawa Street was designed by the noted architectural firm of D. H. Burnham. This postcard photograph looking east from Ottawa Street shows the arched front entry that opens into an atrium patio with a stone water fountain. The building served as an American Legion hall, as well as a restaurant and nightclub, and is part of Joliet Junior College today.

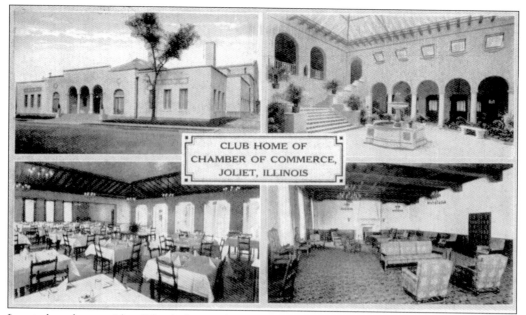

CLUB HOME OF
CHAMBER OF COMMERCE,
JOLIET, ILLINOIS

Located on the east side of North Ottawa Street, the uniquely designed American Legion building housed a number of different business enterprises over the years, including the Joliet Chamber of Commerce. The four pictures on this postcard show an exterior view of the building, the patio, the main dining room, and the lounge. Joliet Junior College's downtown campus, called the Renaissance Center, currently uses the building.

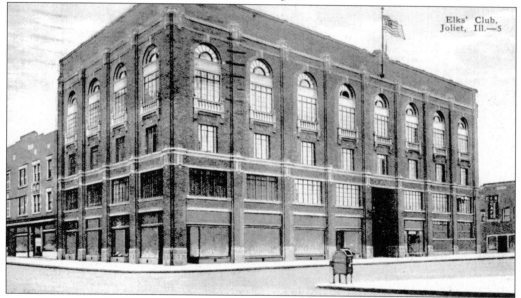

Elks' Club,
Joliet, Ill.—5

The Elks building was located on the northwest corner of Clinton and Scott Streets in downtown Joliet, directly west of the post office. Home to the Elks Lodge No. 296 for many years, the building served several retailers, including Hyman's clothing factory and the Will County Cleaners. One of the unique features of the building was the fourth-floor ballroom. The large arched-shaped ballroom windows can be seen in the postcard photograph.

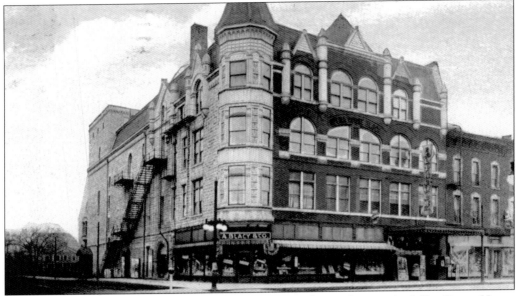

Built in 1873 on the northwest corner of Chicago and Clinton Streets, the Joliet Opera House was one of Joliet's top entertainment venues. The building was also home to several businesses over the years, including A. W. Hays and Company Grocers, Blacy and Company Confectioners, and Hindle's Shoe Shop. The opera house was destroyed by fire in March 1891 and quickly rebuilt. This postcard photograph shows the new opera house building in 1892. Today the new section of the Joliet Public Library stands on the same corner lot.

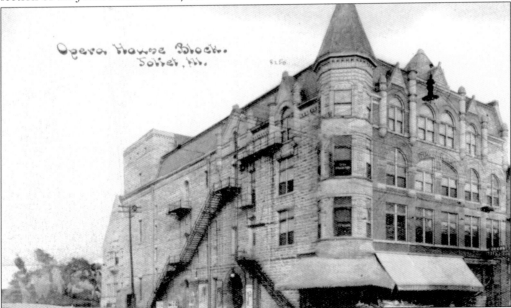

This divided back–era postcard shows the new Joliet Opera House building constructed in 1892 on the corner of Chicago and Clinton Streets. Patrons to the theater entered through the arched doorway on Clinton Street, just below the exterior stairs. The building seen in the photograph just to the west of the opera house is the newly constructed Joliet Public Library, built in 1903.

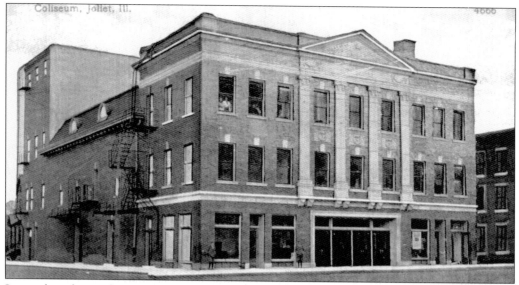

Located on the southeast corner of Chicago and Webster Streets, the Coliseum Theatre building was constructed in 1910 and changed ownership the following year. The new owners renamed the building the Orpheum, and for the next half century, the Orpheum Theatre served as an entertainment and movie venue for patrons. This postcard photograph shows the building looking east from Chicago Street. Missing from the front of the building above the main entrance is the notable Orpheum marquee.

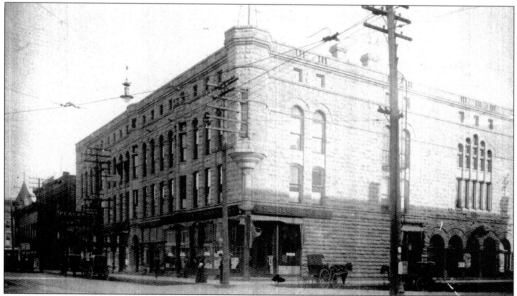

Designed by architect G. Julian Barnes, the auditorium building was built in 1891 from local Joliet limestone. Located on the northeast corner of Chicago and Clinton Streets, the building was home to many businesses throughout the 20th century. Stillman's Pharmacy occupied the corner location for over 50 years, filling prescriptions and serving sodas and ice cream. The sign on the north side of the building along Chicago Street, just in front of the horse-drawn buggy, is for Feagans Jewelry.

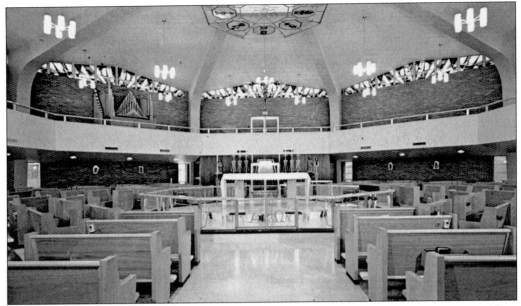

Founded in 1962, Our Lady of Angels Retirement Home is a premier community, providing value-based services to all residents and enhancing their quality of life. As Joliet's only Catholic retirement community, the facility offers services tailored to each individual's needs and preferences as well as a spiritual and loving environment. This postcard photograph shows the inside of the chapel where residents find strength and comfort through meditation and prayer.

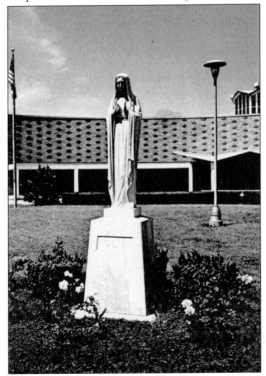

Our Lady of Angels Retirement Home was founded in West Joliet in 1962. Located on Wyoming Avenue, the community is dedicated to providing the best in retirement housing and services to retired religious and lay residents. The residents have spent their entire lives serving others, and Joliet's only Catholic retirement community seeks to give them the happiest retirement possible. This postcard shows the statue of Mary in front of the retirement complex.

In 1897, the Sisters of St. Francis of Mary Immaculate founded an orphanage on the convent grounds. As the number of children in their care grew quickly, a larger building was necessary. In January 1898, the sisters purchased the Fox estate at 117 Buell Avenue for $7,600. The residence was quickly remodeled, a two-story addition was built, and various other improvements were made on the premises. In 1926, the Buell Avenue house became St. Francis Preparatory until it was sold in 1961.

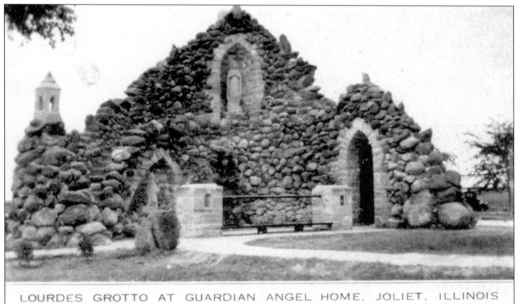

LOURDES GROTTO AT GUARDIAN ANGEL HOME, JOLIET, ILLINOIS

In January 1898, the Sisters of St. Francis of Mary Immaculate purchased the Fox estate on Buell and moved their orphanage to the new location. In 1933, Sr. Julia Lagger, who had a deep devotion to Mary, resolved to build a grotto of Lourdes in front of the main building. The project took two years to complete. The grotto, seen in this postcard photograph, was restored to its original condition by the Guardian Angel Home Alumni Association in 1982.

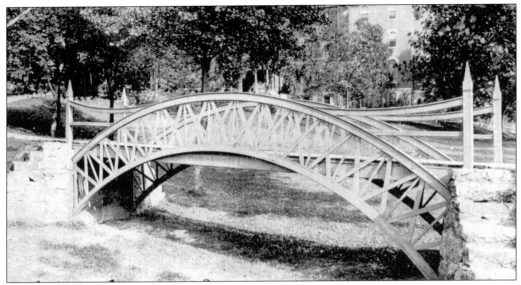

This postcard shows the bridge entrance and walkway to the Guardian Angel Home at Buell Avenue and Plainfield Road. In 1898, the renovated Fox estate was officially dedicated by Archbishop Patrick A. Feehan of Chicago. In 1904, the building was enlarged to house an average of 100 children. The home continued to operate until 1961 when the property was sold. Over the years, Guardian Angel has continuously evolved and created new programs to address specific problems in the community.

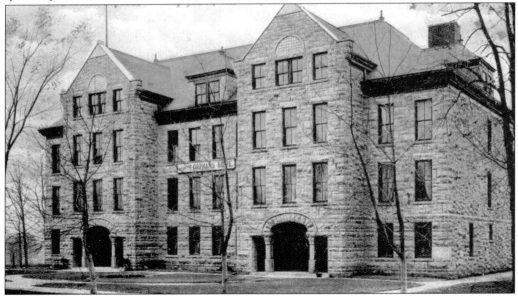

Located on six acres of land southeast of Joliet on South Rowell Avenue near Manhattan Road, construction of the Swedish Lutheran Home for Children began in 1890, and the home opened six years later. The first floor contained dining rooms, furnaces, a kitchen, a playroom, a laundry, and storerooms. On the second floor there was an office, reception room, bedrooms, and an assembly room. The upper two floors were used as wards for children. The institution closed in 1961 when it merged with the Children's Receiving Home in Maywood.

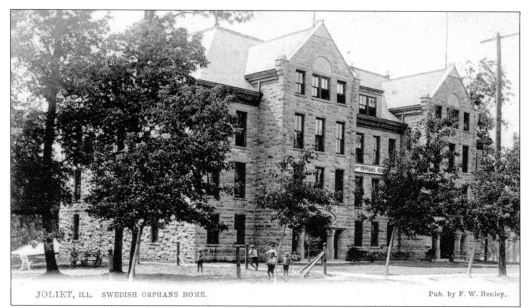

The Swedish Lutheran Home for Children, located at 1323 Rowell Avenue, was incorporated in 1891, and construction of the orphans' home was finished in 1896. Over its 65 years of service to the young, the Swedish Lutheran Home helped nearly 1,500 boys and girls find a haven in the home operated by the Lutheran Social Services. In 1908 and 1911, the Salem Home built additional structures next to the children's home to provide care for the aged.

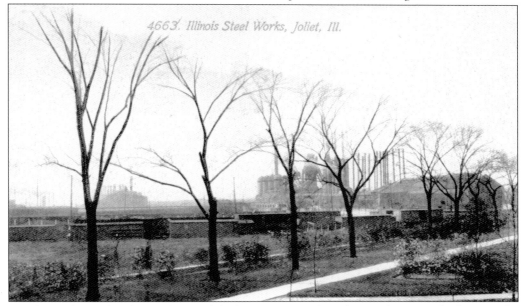

4663. Illinois Steel Works, Joliet, Ill.

On the city's north side stood one of the largest iron and steel manufacturing facilities in the nation. Between 1870 and 1930, the Joliet Iron and Steel Company employed thousands of Joliet area residents, most of them immigrants, who worked and produced iron and steel products, including rails for the nation's growing railroad system. This postcard shows a view of the complex looking south from the grounds of the Illinois State Penitentiary.

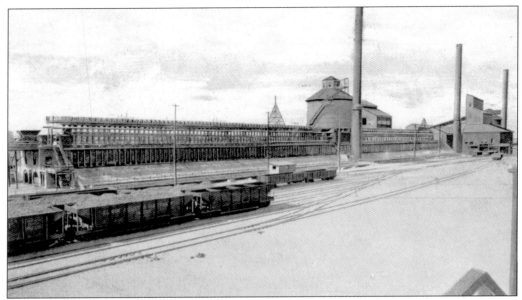

Between 1870 and 1930, iron making and steelmaking were at the heart of Joliet's heavily industrialized economy. There, at the Joliet Iron and Steel Works, thousands of Joliet area residents, most of them immigrants from eastern and southern Europe, worked and produced iron and steel products, including rails for the nation's growing railroad system. This postcard shows a view of the coke ovens at the plant.

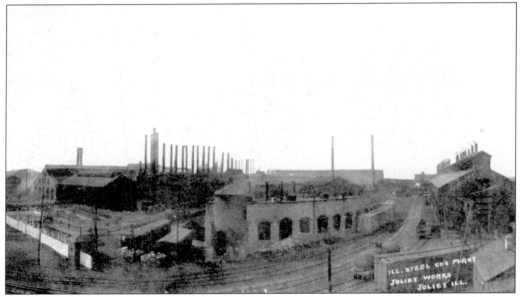

Joliet is known as the "City of Steel" because the town was a major steel-producing center for many years. In the early 1870s, the Joliet Iron and Steel Company was producing iron and steel products. The plant assumed new ownership numerous times and eventually became part of the Illinois Steel Company. This postcard photograph of the Joliet steel mills shows a panoramic view of the plant complex located just north of the city between Collins Street and the Des Plaines River.

This undivided back–era postcard was produced for the 20th anniversary of the Steel Works Club, built by the Illinois Steel Company in 1889. The picture in the upper left corner shows the club building, sometimes known as the "atheneum" because of its library and reading room. In 1932, during the Great Depression, the Steel Works Club closed, and the building was purchased by a religious order and opened as the St. Stephen's Hungarian Chapel in 1937.

In 1889, the Illinois Steel Company built the Steel Works Club on the southeast corner of Collins and Irving Streets. The Steel Works Club was intended to serve as a social, cultural, and recreational center, and for nearly 43 years, employees had many membership privileges through the club. The club offered members from the industrialized neighborhood a library, reading room, gymnasium, billiards, bowling alley, swimming pool, dancing and piano lessons, English classes, and more.

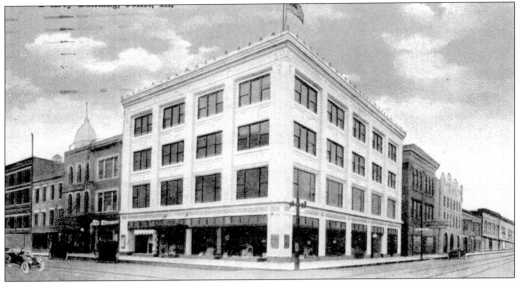

This postcard photograph shows the D'Arcy Building, with Chicago Street in the foreground on the left and Van Buren Street looking west on the right. The four-story D'Arcy Building is also known as the Crystal Square building because for many years the popular Crystal Stairs Theatre was located on the second floor. Looking west down Van Buren Street, the three-story building that housed the Mode Theatre and the G. L. Vance Building, home to the Furniture Emporium, can be seen.

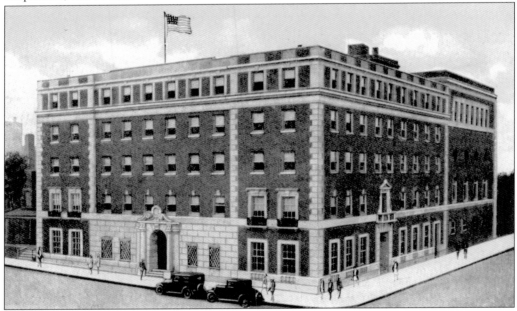

Located at the corner of Ottawa and Webster Streets, the Joliet YMCA building is a good example of Georgian Revival architecture. Completed in 1928, the building was designed by the D. H. Burnham Company architectural firm. The building has a contrasting redbrick and limestone facade with corner quoins, banding, a water table accentuated with stone medallions, columns, capitals at building entrances, and wrought iron railings at the lower windows.

Three

GOVERNMENT FACILITIES, SCHOOLS, AND THE LIBRARY

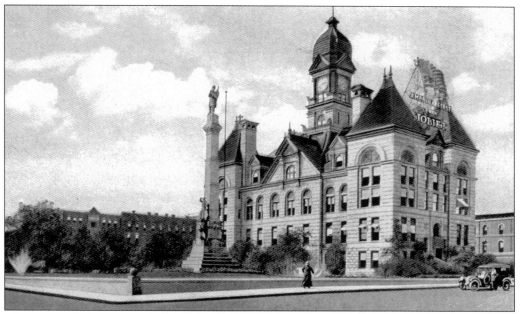

This postcard photograph shows the third Will County Courthouse from the corner of Jefferson and Chicago Streets looking southwest. The third courthouse served the county from 1887 to 1969 and was razed when the fourth courthouse was built in the late 1960s.

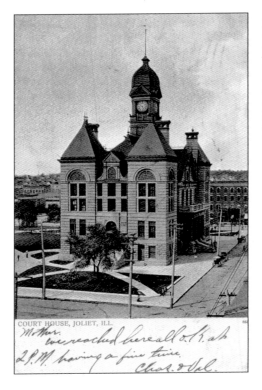

COURT HOUSE, JOLIET, ILL.

Built between 1884 and 1887, the third Will County Courthouse was constructed from Joliet limestone and stood on the public square on west Jefferson Street until its demolition in 1969. Prior to the elevation of the railroad tracks in 1912, the Rock Island Railroad trains would run diagonally across Jefferson and Chicago Streets and through the courthouse yard.

Looking southwest from the corner of Jefferson and Chicago Streets, the third Will County Courthouse and Civil War monument are seen in this postcard photograph. The distinctive high clock tower, colonnaded front portico, and cone-shaped corner structures represent the Federal architectural style. John C. Cochrane, the architect of the building, also designed several other Illinois courthouses, including the Illinois State Capitol in Springfield.

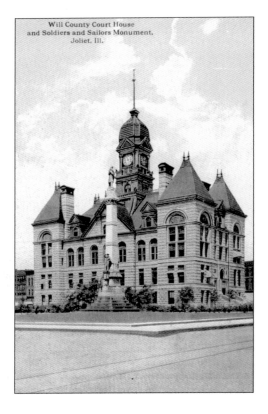

Will County Court House and Soldiers and Sailors Monument, Joliet, Ill.

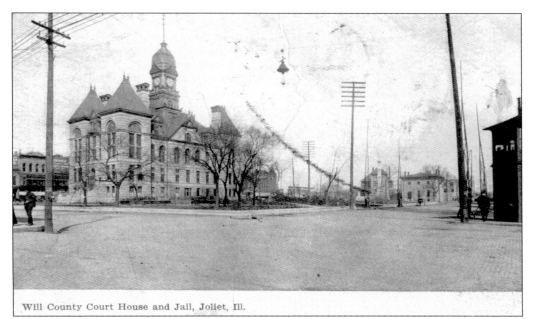

Will County Court House and Jail, Joliet, Ill.

Looking east from the corner of Washington and Ottawa Streets, the rear of the Will County Courthouse can be seen on the left. In the distance, the old sheriff's house and jail can be seen on the northeast corner of Washington and Chicago Streets. The third Will County Courthouse stood on the public square until its demolition in 1969. The sheriff's house and jail were also razed to make room for the new courthouse parking lot.

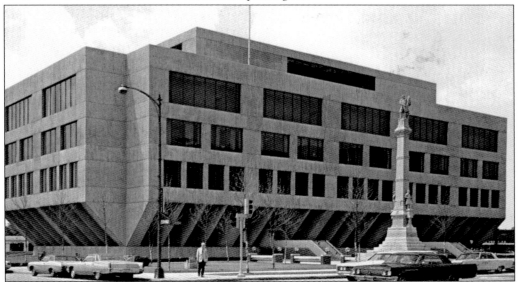

In 1964, the Will County Board of Supervisors voted to demolish the old courthouse building and build a new structure in its place. Built on the public square directly south of the old courthouse, the fourth Will County Courthouse is located on the corner of Ottawa and Jefferson Streets. This *c.* 1970 postcard photograph shows the new courthouse looking south from Jefferson Street. The Civil War monument that was located east of the old courthouse was moved to its new location on Jefferson Street.

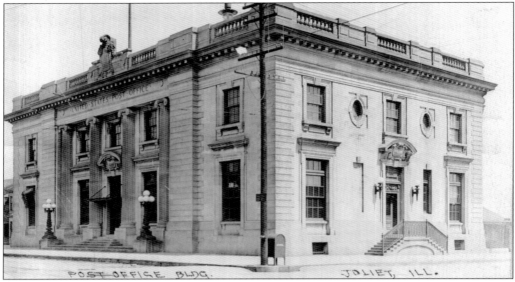

Located at 150 North Scott Street, the new U.S. post office building was open to the public on June 28, 1903. The Scott Street post office was designed by architect Adam Groth and served as the main post office until 1981, when the McDonough Street location was opened. The interior lobby of the new building features some of Groth's famous touches, including a tile floor, Vermont marble wainscoting, heavy oak columns and paneling, and an exquisitely hand-carved stucco ceiling.

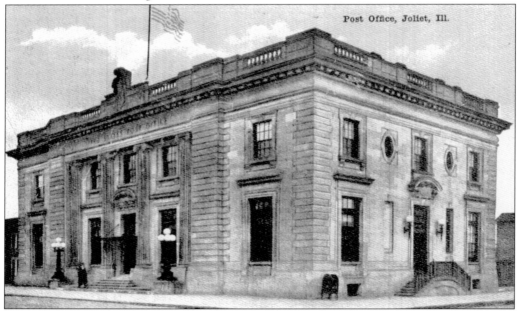

Built by local contractor Adam Groth, the new U.S. post office on the northeast corner of Clinton and Scott Streets opened in 1903. Built in a renaissance architectural style, many people considered the building "among the finest architectural piles of the middle west." The new structure and ground cost the government approximately $130,000. The new post office building served as the main post office for Joliet until 1981.

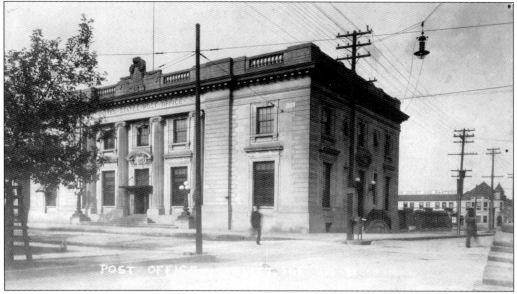

In March 1899, Congress appropriated $100,000 to construct a new post office in Joliet. By July 1903, Adam Groth and Company finished construction of the modest building. The interior of the post office featured marble wainscoting, oak paneling, and hand-carved stucco ceilings. Although the main post office has since moved to its new location on McDonough Street, the old Joliet Post Office has been recognized on the National Register of Historic Places.

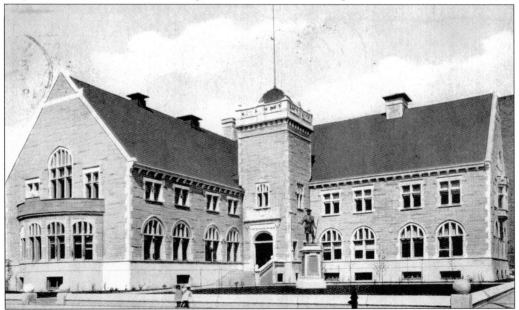

The Joliet Public Library began in 1875 and had several temporary locations in the late 19th century. At the beginning of the 20th century when Joliet decided to build a new permanent home for its library, Daniel Burnham was hired to design it. Located on the northeast corner of Ottawa and Clinton Streets, the limestone structure was built by Adam Groth and Company at a cost of $175,000. A statue of Louis Jolliet is located near the front entrance.

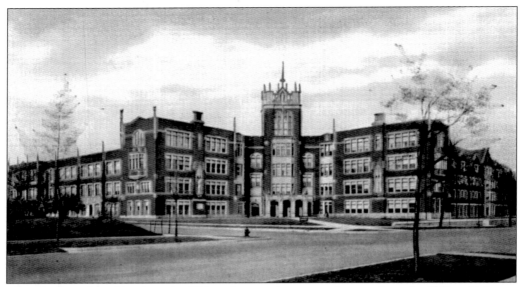

The Third Order of St. Francis of Mary Immaculate opened an academy in 1869, which was eventually expanded to the college level in 1920. Five years later, the college was opened to the public as Assisi Junior College. As upper-level classes were added, the name was changed to the College of St. Francis in 1930. Located at the northeast corner of Wilcox and Taylor Streets, Tower Hall was constructed in 1922 (renovated in 1984) and housed St. Francis Academy from 1924 to 1956.

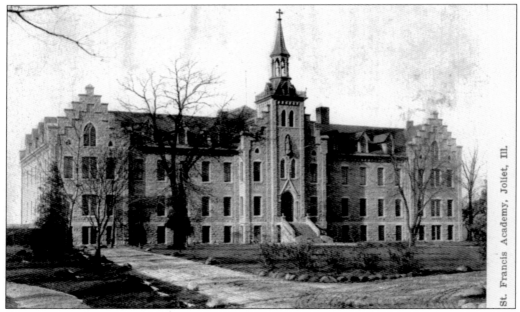

St. Francis Convent and Academy were built and completed in 1882 on the edge of the city. Located on Plainfield Road and Taylor Street, the academy earned a reputation of excellence in education and even earned awards at the World's Columbian Exposition in Chicago. This postcard photograph shows the original building, before the 1915 academic wing was added and the school reopened.

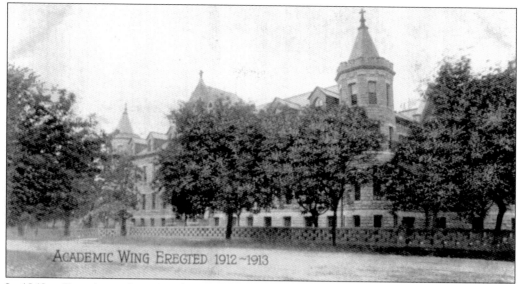

ACADEMIC WING EREGTED 1912~1913

In 1869, a Franciscan sister, Mother Alfred Moes, founded St. Francis Academy. The academy opened with only a few girls, who were schooled in a small stone house, owned by Jacob Hausser, near Broadway and Division Streets. In August 1882, St. Francis Academy moved into a newly erected building on Plainfield Road and Taylor Street. This postcard photograph shows the new academic wing, located at 603 Taylor Street, with facilities and faculty available for kindergarten through high school students.

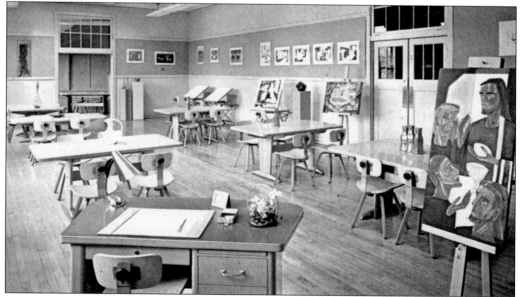

In 1930, the Assisi Junior College name was changed to the College of St. Francis, and the college received approval for a four-year liberal arts college for women. Young women were quick to take advantage of the small but highly rated college in Joliet. During the 1940s, many new fields of study opened to St. Francis students, and three new majors were introduced, including art. This postcard photograph from the late 1950s shows the largest of the four art studios at the college.

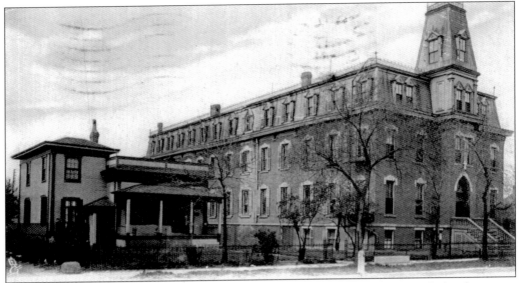

Built in 1883 on the southwest corner of Ottawa and Cass Streets, St. Mary's Academy was established by the Sisters of Loretto for young children to provide the proper mental and physical training to students that would give them a solid and refined education. Music, drawing, painting, Latin, French, German, and English were all given particular attention in the school curriculum. In 1918, Providence High School had its beginning in this building before moving to its present campus in New Lenox.

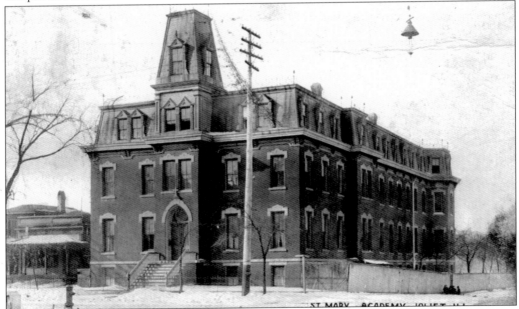

The Sisters of Loretto came to Joliet from Toronto, Canada, to establish a school in connection with St. Mary's Carmelite Catholic Church. The sisters began the school in a residence owned by H. S. Carpenter on Cass Street until it became too small to accommodate the growth of the school for young children. In 1883, the three-story building on the southwest corner of Ottawa and Cass Streets was constructed, and the sisters moved the school to the new building.

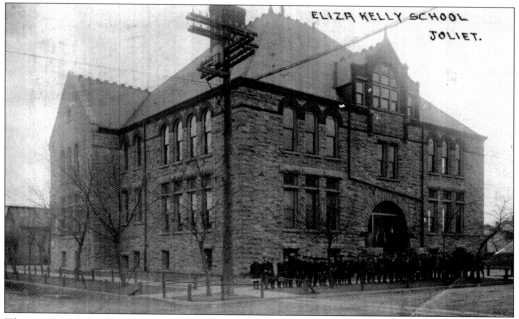

The original Eliza Kelly School (the Joliet Street School) was a three-story stone structure built in 1889 and located on the southwest corner of Joliet and McDonough Streets in south-central Joliet. The original stone building was rebuilt in 1919 on the same site. The school was renamed in 1902 for Eliza Kelly, principal at the original Joliet Street School in 1889. This postcard shows the original school structure around the start of the 20th century. The Eliza Kelly School was closed in June 2004.

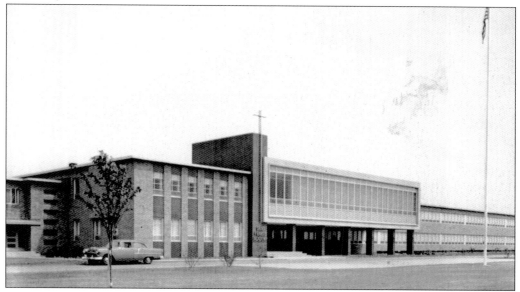

In 1882, St. Francis Academy relocated to the edge of the city, near Plainfield Road and Taylor Street, and was an all-women's college; it remained there until 1956, when it moved to a location at Larkin and Ingalls Avenues. That location is still open today as Joliet Catholic Academy, which is the result of the 1990 merger between St. Francis Academy and Joliet Catholic High School.

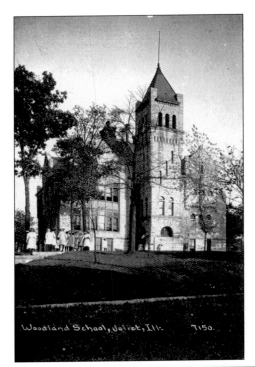

Named for its woody location east of downtown, Woodland Park School was built in 1893 near Third and South Rowell Avenues. In 1900, there were eight teachers and 382 students. By the early 1920s, the school was commonly called the Woodland School. In 1969, a new modern structure was built within the same school block, so classes could be still held in the old school during the construction process. An addition was constructed in 2004. This postcard photograph shows the old Woodland Park School.

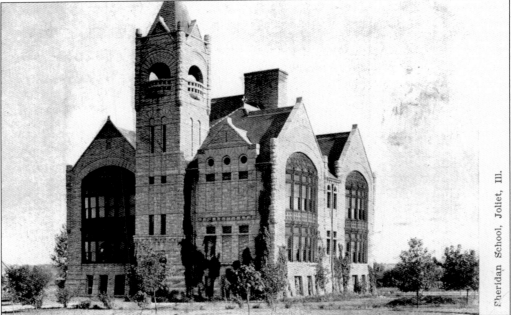

The original Sheridan School, pictured here, was built in 1893 south of Route 52 (West McDonough Street) near the corner of Munroe and South Market Streets. A new school building was constructed on the same property in 1969, and the old school was razed. The new Sheridan School was closed at the end of the 1982–1983 school year and has since been used as the Joliet School District 86 buildings and grounds headquarters and materials distribution center.

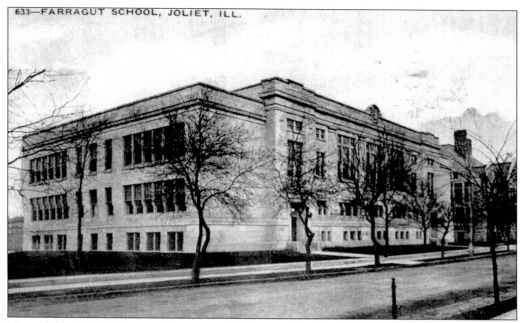

Named for David Glasgow Farragut, a Union naval officer in the Civil War who became noteworthy in the battle of Mobile Bay, Farragut School was built in 1899 in Preservation Park near the northwest corner of Glenwood Avenue and Wilcox Street on the city's west side. Additions to the original school were built in 1915, 1925, 1928, and 2004. Farragut Elementary served grades 1-8 until Hufford Junior High was opened at the start of the 1957–1958 school year. The photograph below shows the original school, and the photograph above shows the later addition just west of the old school on Glenwood Avenue.

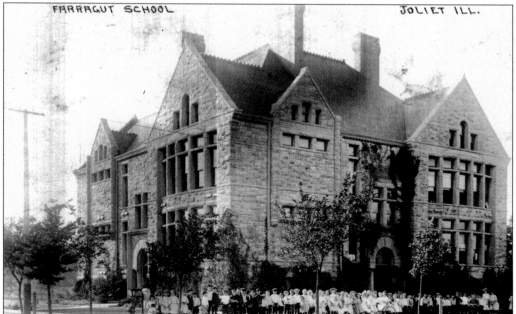

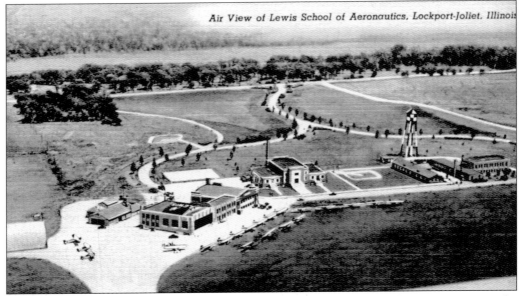

Founded in 1932 under the direction of the Chicago archdiocese, Lewis University began as the Holy Name Technical School, a school for boys, which opened with 15 students. The school was established on a campus of 160 acres of farmland that was donated to the archdiocese. The Lewis School of Aeronautics was incorporated in 1934, and in the late 1930s, an airstrip was built on campus. This airstrip was the origin of what became Lewis University Airport.

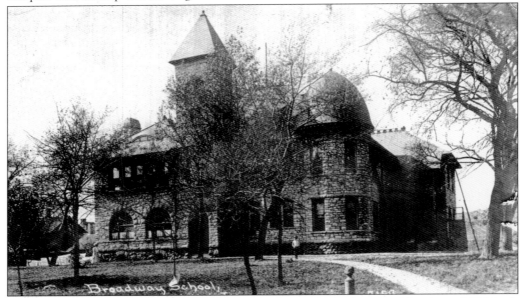

Erected in 1888 from local limestone and located on the near west side of the city at 305 North Broadway Street (between Western Avenue and Spring Street), Broadway School was one of the most interesting and picturesque institutions in the Joliet public school system. Designed by prominent Joliet architect F. S. Allen, the school was located in one of the most historical spots in town because it was built on the site of the "Old Stone School" and across the street from the former site of Fort Nonsense.

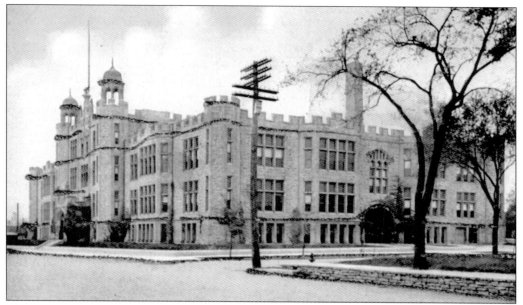

The old Joliet High School was located on the corner of Chicago and Webster Streets. By 1899, overcrowded conditions prompted voters to establish a new township high school and approve the purchase of a new site for the construction of a new school. In 1901, the Joliet Township High School was open to the 600 students enrolled that year. Designed by F. S. Allen and built in the Collegiate Gothic style, the building was constructed primarily of Joliet limestone, and, for decorative detailing, Bedford stone was used on the exterior. Over 100 years later, the building still operates as a school and is commonly known as Joliet Central High School. The photograph above is a view from the corner of Eastern Avenue and Jefferson Street. The photograph below is a view looking east near the corner of Van Buren Street and Eastern Avenue.

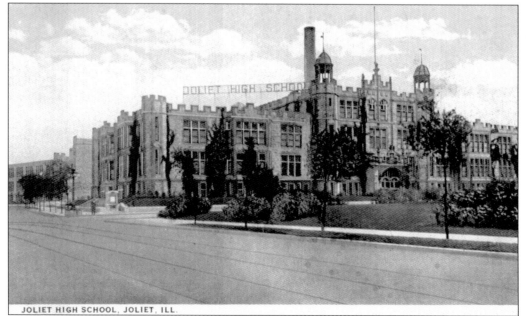

JOLIET HIGH SCHOOL, JOLIET, ILL.

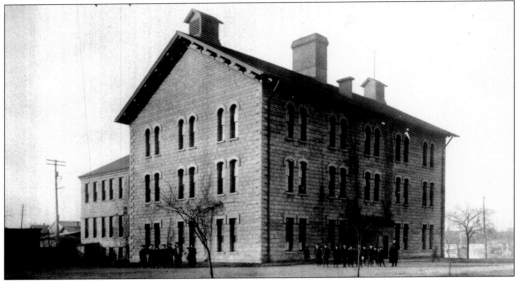

The three-story Eastern Avenue School was built in 1863 and located on the southeast corner of Eastern Avenue and Cass Street, just west of Herkimer Street. In December 1915, the superintendent of schools declared the building a firetrap and said the building should be rebuilt or abandoned. The old Eastern Avenue School was razed, and in 1916, a new school was constructed on the same site and was named the F. E. Marsh Elementary School. Marsh was a Joliet native who served on the first school board and ran a grain business in Plainfield and a bootery in downtown Joliet.

Located in downtown Joliet on the northwest corner of Scott and Webster Streets, Central School consisted of two separate buildings—the Roosevelt building and the Central building. The Roosevelt building, located on the northeast corner of Chicago and Webster Streets, was a three-story stone structure built in 1881, and the Central building was a brick building constructed in 1908. The Roosevelt school served as the city's public high school until a new building on Jefferson Street was constructed in 1901. Central School (junior high) closed in 1956 when it was razed to make room for JCPenney's and Woolworth's.

Four

Churches, Hospitals, Hotels, and Banks

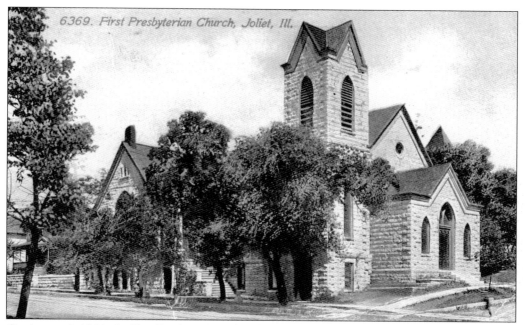

6369. First Presbyterian Church, Joliet, Ill.

On August 3, 1866, the First Presbyterian Church was organized, with 28 members at the home of H. N. Marsh. By the following year, the congregation built a new church, using locally quarried limestone, on the corner of Western Avenue and Broadway Street. The new church was dedicated on December 22, 1867. By 1925, the church had outgrown its location, and construction of a new English Tudor Gothic–style church began at the corner of Western and Raynor Avenues. This postcard shows the original old stone church.

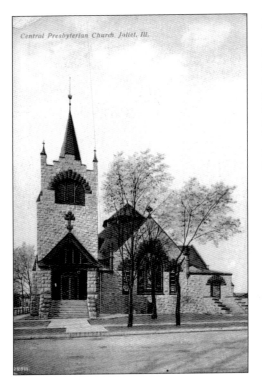

Central Presbyterian Church, Joliet, Ill.

Built in 1895 with Joliet limestone, the new Central Presbyterian Church was constructed under the architectural direction of Knox and Elliott. Looking west from Richards Street, this postcard photograph shows the main entrance and bell tower of the new church. On May 12, 1950, a wedding that attracted national attention took place in the church. Katherine Woodruff, daughter of Frederick Woodruff, married Marshall Field Jr., who is the son of the founder of Marshall Field's of Chicago.

The Central Presbyterian Church, located on the northwest corner of Richards Street and First Avenue, was built in 1895 and dedicated two years later with Royal E. Barber as guest speaker. Organized as a church in 1844, the first Central Presbyterian Church was built in downtown Joliet on the southeast corner of Ottawa and Van Buren Streets. The new Presbyterian Church was built on the east side of the city as the population of Joliet moved from the city center.

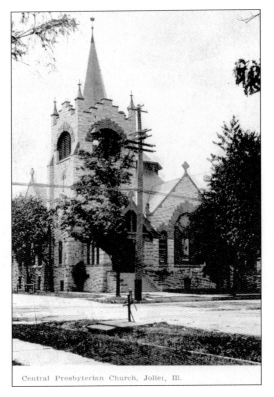

Central Presbyterian Church, Joliet, Ill.

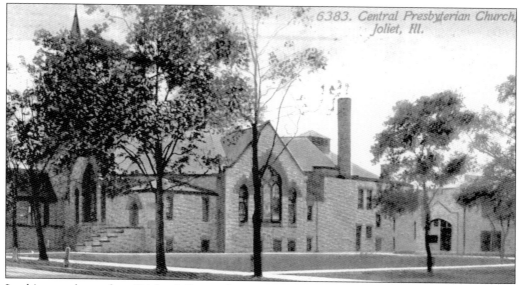

Looking southwest from Richards Street, this postcard photograph shows the Central Presbyterian Church in the early 20th century. Located on the northwest corner of Richards Street and First Avenue, the church was built in 1895 under the direction of Rev. D. C. Milner. The bell that rang for over 40 years in the tower of the old downtown Presbyterian church was placed in the belfry of the new church. The bell was purchased in the 1850s at a cost of $500 and for many years was the only bell in town. It rang for fires as well as church services.

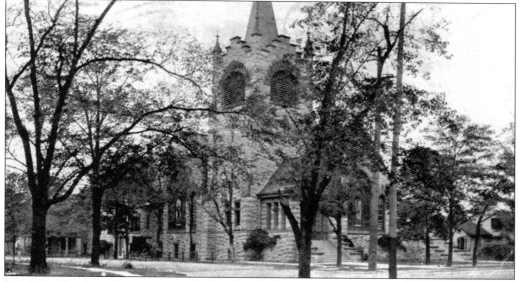

In 1844, the first Congregational church of Joliet was organized under the direction of Rev. B. W. Dwight. These first meetings took place on the third floor of Merchant's Row off Bluff Street. In 1852, the Central Presbyterian Church was built at the southeast corner of Ottawa and Van Buren Streets in downtown Joliet. The church went through a transitional period in the late 1890s, and plans were made to construct a new church on the east side of the city. Construction began on the Central Presbyterian Church in 1895 on the northwest corner of Richards Street and First Avenue.

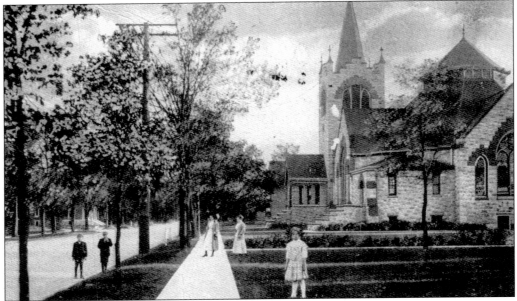

Looking south on Richards Street near First Avenue, the new Central Presbyterian Church can be seen on the right. Built of locally quarried Joliet limestone, the church was constructed in 1895 on Joliet's east side as persons of wealth and influence began moving away from the downtown area. Richards Street at the beginning of the 20th century was a tree-shaded street where the fashionable persons of wealth and influence lived. Today the old Central church is listed on the Illinois Register of Historic Places.

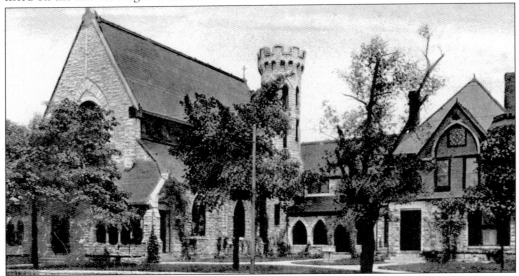

In May 1835, Bishop Philander Chase and eight area residents convened a communion service forming a parish at the home of Joliet's first physician. By 1857, members worshiped in a small wooden structure featuring stained-glass windows at the northeast corner of Joliet and Van Buren Streets. In January 1887, the Episcopal Church clergy consecrated the new church, constructed of Joliet limestone. On October 8, 2006, an early-morning fire swept through Christ Episcopal Church, gutting the old structure.

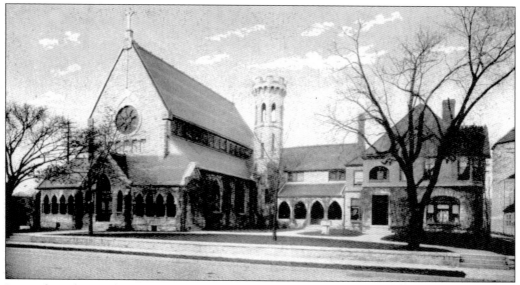

Located on the northeast corner of Van Buren and Joliet Streets, Christ Episcopal Church was designed by F. S. Allen and built in 1887. By 1926, the parish hall, parsonage, and chapel were finished. Designed in an English High Gothic Revival style, the Episcopal parish was once the second oldest in the metropolitan Chicago area. In January 2004, the members celebrated their final Eucharist at the church, as the small congregation merged with St. Edward's Episcopal Church on Midland Avenue.

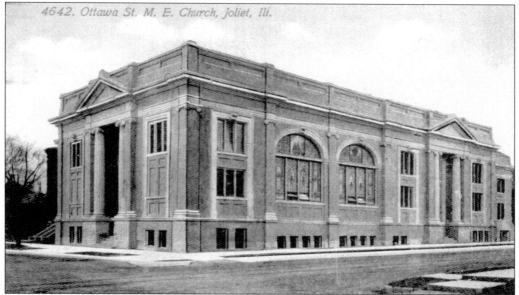

The cornerstone of the Ottawa Street Methodist Church was laid with a fitting ceremony by Bishop John H. Vincent on November 21, 1909. Located on the northeast corner of Ottawa and Cass Streets, the two-story building was completed in 1910. The congregation worshiped in the church until 1996, when it merged with Grace United Methodist Church on Avalon and Larkin Avenues. In 2002, the Ottawa Street building became part of the new Joliet Area Historical Museum complex.

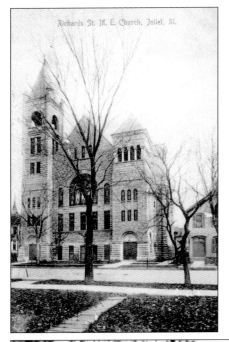

Historical records show that the Richards Street church was founded as a mission in 1872. The first church was built in 1877 and stood at the rear of the present church. The same year, the name of the church was changed from the Centennial Methodist Episcopal Church to Richards Street Methodist Church. Looking east from the corner of Richards Street and Second Avenue, the present structure was built in 1890 by contractor Harry S. Brockman. The massive limestone church is a blend of Gothic and Victorian Romanesque styles.

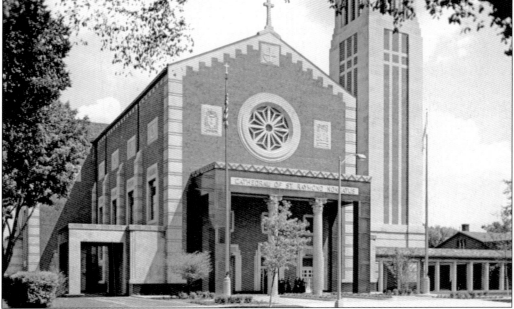

In 1917, St. Patrick's Catholic Church, Joliet's oldest Catholic church, was subdivided to form St. Raymond's Parish and better serve the Catholics on the northwest side of the city. Fr. Francis Scanlan was appointed the first pastor. On April 28, 1918, the cornerstone was set at the first St. Raymond church located at 705 Douglas Street. By the 1940s, the old vintage church building was too small for the growing community and construction on a new church began in 1953. This postcard photograph shows the new redbrick and granite church on North Raynor Avenue that was dedicated on May 26, 1955.

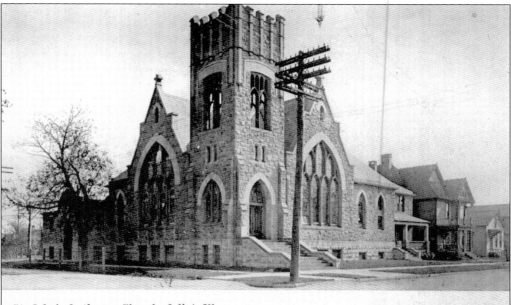

St. John's Lutheran Church, Joliet, Ill.

St. John's was founded on February 8, 1903, as the first English-speaking Lutheran church in the Joliet area, with a congregation of 20 members. Five years later, on May 31, 1908, the original St. John's English Lutheran Church at 58 Herkimer Street was dedicated. In 1979, the congregation sold the old church for $20,000 and construction began on the new church on Plainfield Road in northwest Joliet. The new church was dedicated on August 2, 1981. Both postcard photographs show the original church looking southeast from the corner of Herkimer and Van Buren Streets.

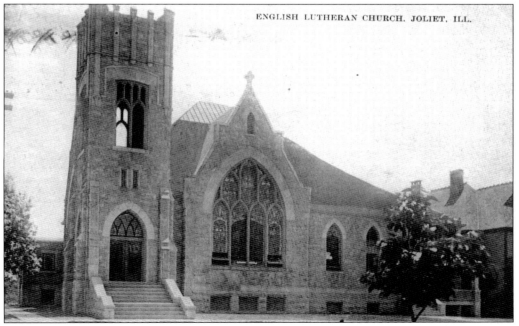

ENGLISH LUTHERAN CHURCH. JOLIET, ILL.

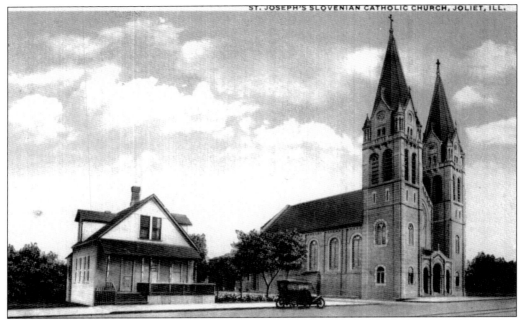

The historic St. Joseph Church, located on North Chicago Street, was established in 1891 to serve the growing community of Slovenian immigrants who had settled in Joliet at the end of the 19th century. The present church building, with its distinctive dual spires and silver hue, was built in 1905 from Indiana limestone. The postcard above shows the church looking southeast from the corner of Chicago and Clay Streets. The postcard below was produced to celebrate the 40th anniversary of the parish in 1931. The buildings shown in the photographs include the convent, the rectory, the parish hall, the church, and the school. A photograph of the Rev. John Plevnik is located above the church.

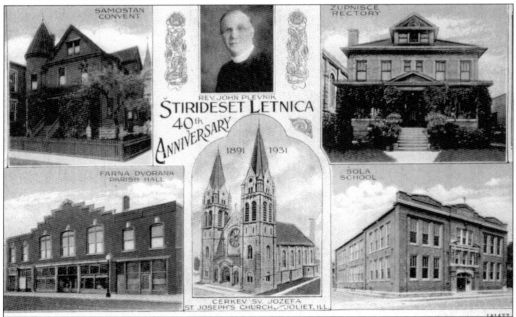

64

St. Patrick's Catholic Church was established in 1838 by the Bishop of Vincennes, Indiana, and became the first Catholic church created in northern Illinois and the second-oldest Catholic church in the entire Illinois metropolitan region. Fr. John Francis Plunkett was appointed the first pastor, and construction began on a new stone church on Broadway Street, just south of Exchange (Jefferson) Street. This postcard photograph shows the original building on Broadway Street. In 1919, a new church was erected on West Marion Street and has been the home of St. Patrick's Catholic Church ever since.

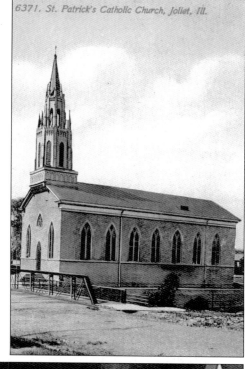

6371. St. Patrick's Catholic Church, Joliet, Ill.

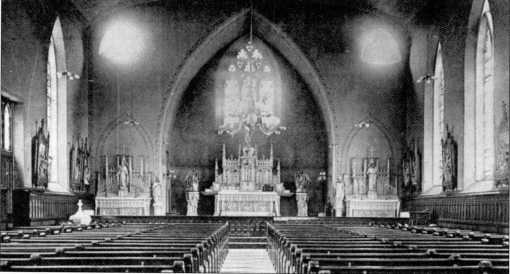

This postcard photograph shows the interior of the original St. Patrick's Catholic Church located on the southwest corner of Broadway and Exchange Streets. The inside of the church is laid out in a traditional manner with a communion rail separating the nave from the sanctuary. The buildings behind the center altar are referred to as the "City of God," and the altar is turned to face the tabernacle in the center of the city. The figures on the smaller altars are Mary on the left and Joseph on the right. The hanging objects on the walls around the periphery of the church are the stations of the cross.

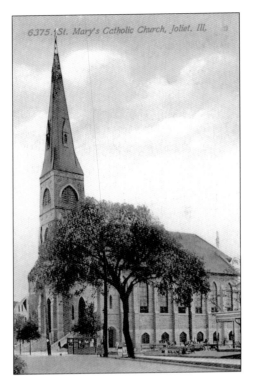

St. Mary's Carmelite Catholic Church has been a downtown Joliet landmark since its construction in 1882. Located on the southwest corner of Ottawa and Clinton Streets, construction of the limestone church began in 1877, and the church was dedicated in August 1882. Construction of the Gothic-style church was halted briefly as concerned residents began legal proceedings over the issue of the church bell ringing in a residential area. The church was closed by the Diocese of Joliet in 1991 because of the small number of worshipers in the congregation.

Located on the southwest corner of Ottawa and Clinton Streets, St. Mary's Carmelite Catholic Church was dedicated on August 15, 1882. Built from locally quarried limestone, construction on the Gothic Revival–style church began in 1877. For more than 130 years, the 200-foot central spire of St. Mary's soared above the skyline of the city. As the number of downtown worshippers to the church dwindled, the Diocese of Joliet closed the church in 1991.

St. Mary's Church, Joliet, Ill.

Located east of downtown Joliet at the corner of Benton and Cassidy Streets, the First Bethlehem Lutheran Church was dedicated on January 1, 1884. The church traces its origin to the Swedish migrants of the late 19th century who came to Joliet and organized the church in 1882. Nils Flint, who is pictured in the inset photograph, was the sexton for 22 years and passed away on October 4, 1914. This church was torn down, and the Second Bethlehem Lutheran Church was built on the southeast corner. Dedicated on October 31, 1915, the second church remains open today at 412 East Benton Street.

Mr. N. N. Flint who died October 4, 1914 and the church he served as janitor for 22 years

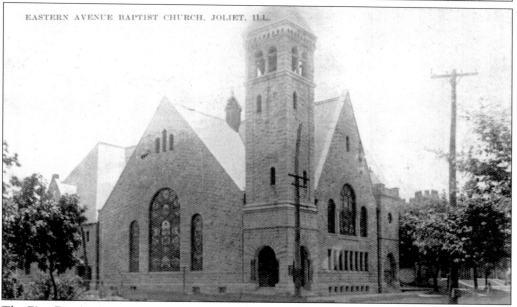

EASTERN AVENUE BAPTIST CHURCH, JOLIET, ILL.

The First Baptist congregation organized in 1837 and built a church on the northeast corner of Scott and Van Buren Streets in 1852. In 1890, the church split into two groups and built separate churches east of town. Eastern Avenue Baptist Church, located at Van Buren Street and Eastern Avenue, was dedicated in 1893 and the other group built a church at Baker and Second Streets. In 1917, the Joliet Township board bought the Eastern Avenue Baptist Church property for school additions. By 1921, the two groups reunited and built a new church on the northwest corner of Clinton Street and Eastern Avenue.

The Universalist Unitarian church began in 1836 as the St. John's Universalist Church and Society. In 1856, the first stone church was built on the northeast corner of Clinton and Chicago Streets. By the 1870s, membership began to decline and a decision was made to raze the old stone church and replace it with a multipurpose structure that would combine commercial, civic, cultural, and religious uses. Built by the congregation in 1891, the auditorium building became the new multipurpose structure. The congregation used the second floor of the new building for worship purposes. The postcard above shows the inside of the worship area in the early 20th century, and the postcard below shows the auditorium building on North Chicago Street.

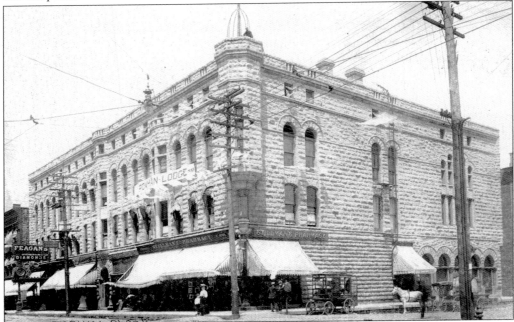

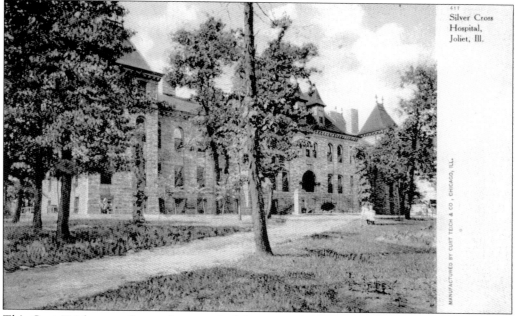

This Curt Teich–manufactured postcard of the original Silver Cross Hospital building is from the divided-back era. Written to Beulah Stellwagen of Tinley Park, the correspondence on the back reads, "Hello Beulah, How are you? I am feeling fine. Tell your mamma that she can have some butter by to-morrow. From your schoolmate Sophie."

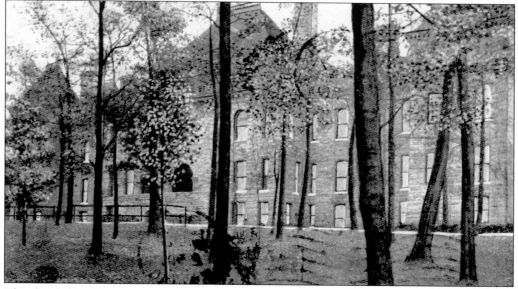

This divided back–era postcard of Silver Cross Hospital shows a view looking north through the wooded property on Walnut and East Eagle Streets. Mailed on August 7, 1911, the correspondence on the back of the postcard reads, "Dear Minnie, We arrived home safely at eight o'clock last night. We had no rain all the way. Did you get wet? We saw the rainbow at the electric part at Plainfield and then the sun shone till it went down. Ma sends so many thanks for all you sent. I will write a letter later."

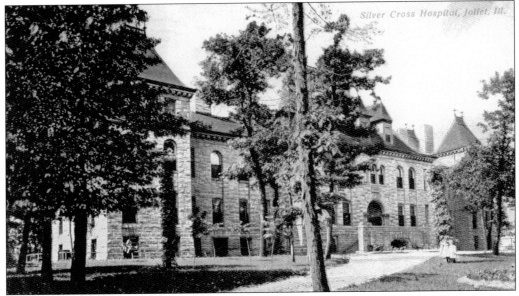

This postcard shows a photograph of the original Silver Cross Hospital building that was constructed in 1895. Looking north from Walnut and East Eagle Streets, the three-story limestone structure and main entrance designed by William Le Baron Jenney can be seen. Over the years, several additions were made to the hospital, including the removal of the original building, and eventually the complex evolved into a modern medical center.

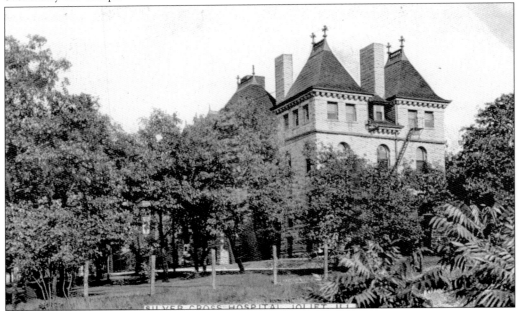

When the newly constructed 33-bed hospital opened in October 1895, it provided much-needed health care services to residents of the east side of Joliet. Designed by noted architect William Le Baron Jenney and completed at a cost of $39,907.07, the original three-story building, pictured here with its Romanesque arches and large corner towers, was eventually razed in 1983 to make room for new buildings that were part of the modern medical complex.

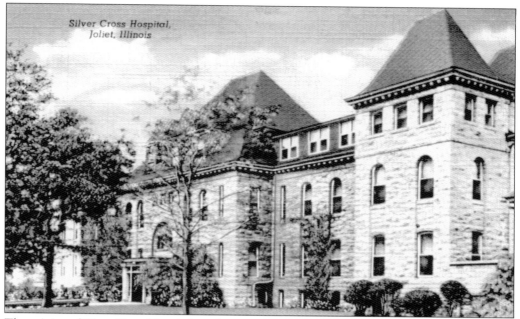

Silver Cross Hospital,
Joliet, Illinois

The origins of Silver Cross Hospital can be traced to the Will County Union of King's Daughters and Sons that organized in 1890 and spent the next five years planning the construction of a new hospital. The groundbreaking took place in 1892, and construction of the new hospital began the next year. Located in the Hickory Hills area of Ridgewood, Silver Cross Hospital was designed by architect William Le Baron Jenney, the father of the modern skyscraper, and was completed in 1895.

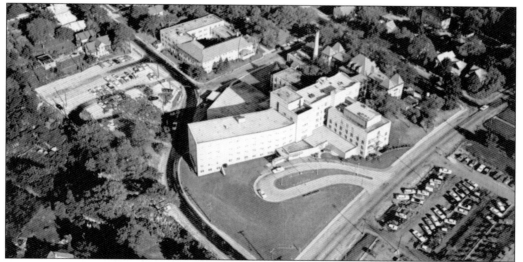

Looking northeast from Maple Road and Walnut Avenue, this aerial photograph shows the Silver Cross Hospital campus and circle driveway off Walnut. Located in the Hickory Hills area of Ridgewood, this photograph from the early 1960s shows how the hospital had already begun to expand. Notice the original hospital building on East Eagle Street, designed by William Le Baron Jenney, just to the south of the newer facility additions. The original building was razed in 1983.

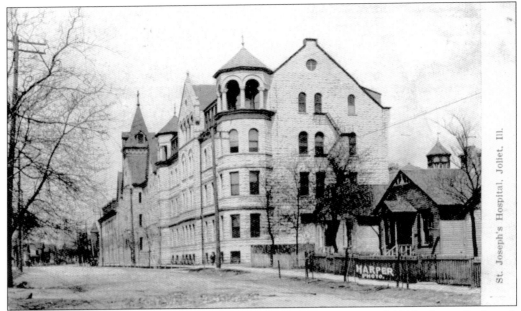

This postcard photograph, looking north on Broadway Street around 1908, shows St. Joseph Hospital on Joliet's near west side. The four-story limestone structure was founded in 1882 and expanded over the years until there was no longer any room. In 1950, land was purchased on the far west side and a new hospital was built. On January 26, 1964, patients were moved from the Broadway location to the new hospital on North Madison Street. The postcard pictured below is the new St. Joseph Hospital at 333 North Madison around 1965.

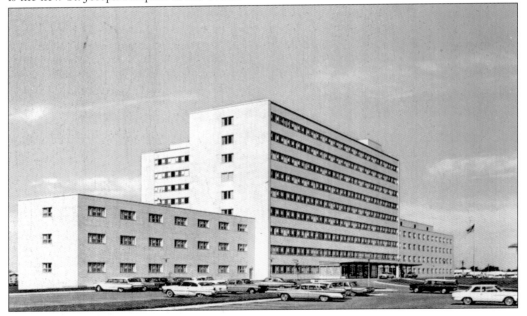

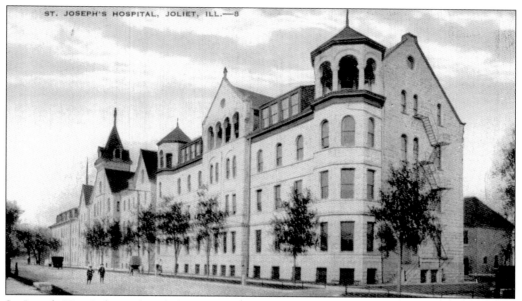

St. Joseph Hospital was founded in 1882 by the Franciscan Sisters of the Sacred Heart shortly after typhoid fever and small pox had swept throughout the community. Located at 372 North Broadway Street, just south of Division Street, the hospital began with 20 beds and served the residents of the west side until 1964 when 102 patients were moved to the new facility on North Madison Street.

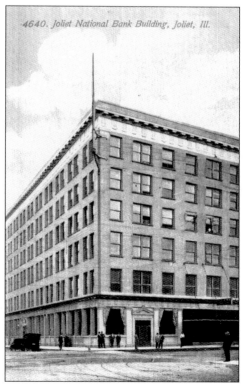

4640. Joliet National Bank Building, Joliet, Ill.

This postcard shows a photograph of the Joliet National Bank building in the early 20th century. Located on the southeast corner of Clinton and Chicago Streets, the Joliet National Bank had operated from this location for many years. Before the bank built this six-story building, the Joliet National Bank operated out of the first floor of the old Munroe Block building, located on the same downtown corner. The familiar flagpole on the corner of the building can be seen in this photograph.

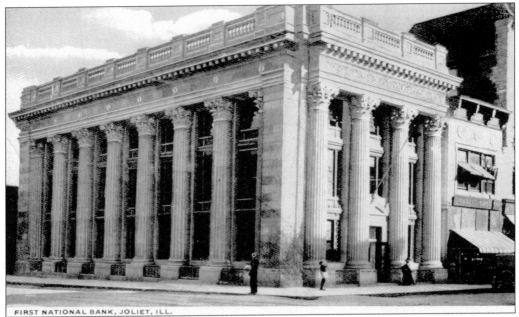

FIRST NATIONAL BANK, JOLIET, ILL.

Located on the southeast corner of Chicago and Van Buren Streets since 1910, the First National Bank has been a familiar landmark to many Joliet residents. Created by the Chicago firm of Mundie and Jensen, the Romanesque structure, with its Corinthian columns, roofline balustrade, and decorative frieze on the front of the building, presents a distinguished exterior facade. Before moving to this location, the First National Bank was located at 110–112 North Ottawa Street. The *c.* 1910 photograph postcard below was taken from the northwest corner of Chicago and Van Buren Streets. Caswell Livery Company can be seen just east of the bank on Van Buren Street and the four-story Barber Building is visible on the right just south of the bank on Chicago Street.

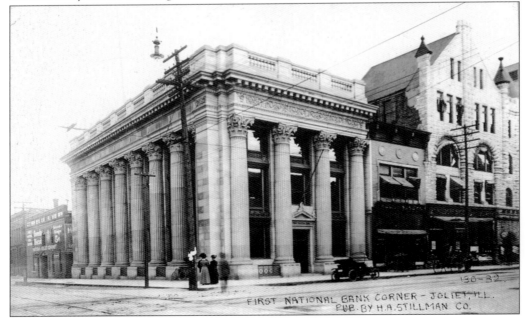

FIRST NATIONAL BANK CORNER - JOLIET, ILL.
PUB. BY H.A. STILLMAN CO.

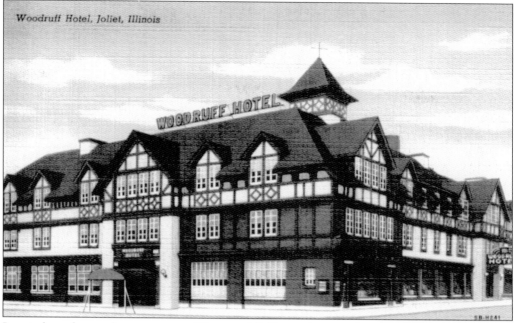

Woodruff Hotel, Joliet, Illinois

Located on the southwest corner of Scott and Jefferson Streets, the Woodruff Inn opened for business on November 1, 1915. With 102 guest rooms, a large inviting lobby, an inner courtyard that provided guests with an outside tranquil setting, and a fine cuisine prepared by chef Marcel A. Pfister, the English-style architecture of the Woodruff Inn made guests comfortable during their stay in Joliet. The postcard photograph below shows a view of the dining room and the finely set tables around 1920. During this era, Paul Schoene was the manager of the hotel. The hotel was razed on December 21, 1971, ending an era as a distinctive downtown landmark.

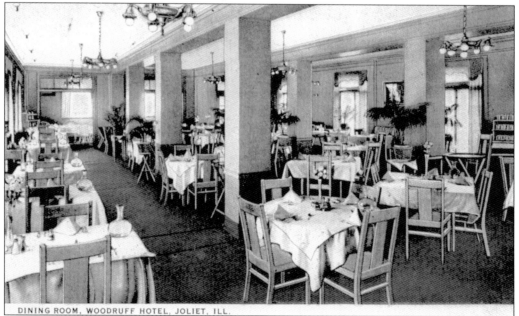

DINING ROOM, WOODRUFF HOTEL, JOLIET, ILL.

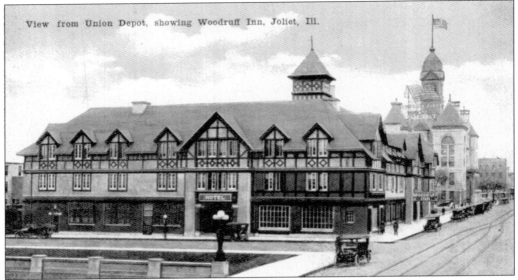

Looking west on Jefferson Street from the union depot, the familiar downtown landmark of the Woodruff Inn can be seen on the left in the foreground. Built in 1914, in an old–English architectural style, the 102-room hotel offered guests some of the finest amenities found in the area. The interior of the hotel included rooms furnished with oak furniture, velvet carpeting, chandeliers, and paneled walls. Guests had access to a tailor shop, a barber, private telephones, and a car mechanic.

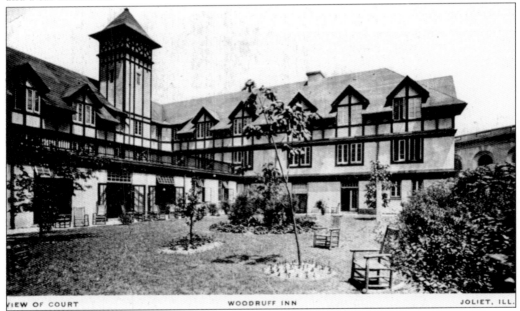

VIEW OF COURT WOODRUFF INN JOLIET, ILL.

Guests at the Woodruff Inn could find a refuge from the outside world in the hotel's inner courtyard. The old-English architecture of the hotel and the beautiful landscaping provided a wonderful backdrop for guests who wanted to sit in the rocking chairs and enjoy the warm outside air. This picture postcard shows a view of the outside courtyard. The Woodruff Inn was razed in 1971 to make room for new public parking near the new courthouse.

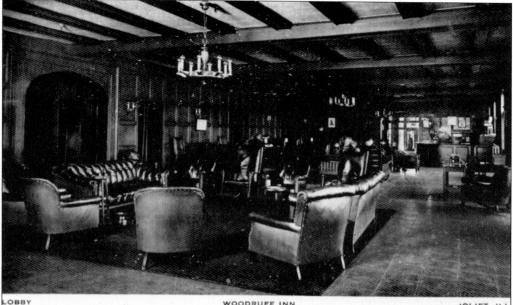

LOBBY WOODRUFF INN JOLIET, ILL.

The inside of the Woodruff Inn provided guests with a comfortable place to relax and unwind. This picture postcard shows a view of the large lobby with its beamed ceiling, hanging chandeliers, leather chairs and sofas, oak tables, rocking chairs, and fireplace. Spending time in the lobby with friends or sitting by oneself on the comfortable furniture and reading a book, the lobby was certainly a pleasant place to spend time while at the Woodruff Inn.

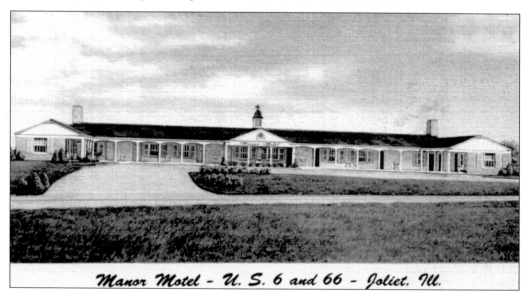

Manor Motel - U. S. 6 and 66 - Joliet, Ill.

In 1940, Route 66 was realigned to pass through Plainfield and Channahon and bypass downtown Joliet. Multiple additional alignments were done over the subsequent years while building the interstate. Located along the new Route 66 alignment in Channahon, the Manor Motel, built in the 1950s, offered the "Mother Road" traveler a nice place to spend the night. This linen-era postcard offers a panoramic photograph of the motel complex looking east from old Route 66.

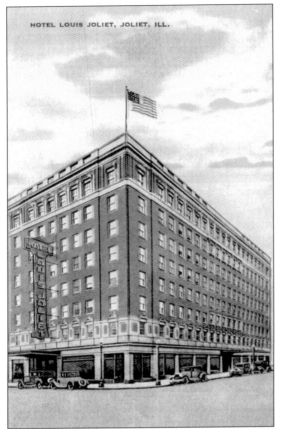

HOTEL LOUIS JOLIET, JOLIET, ILL.

Regarded for many years as Joliet's most elegant hotel, the Louis Joliet Hotel opened for business in 1927 on the southwest corner of Scott and Clinton Streets. Built by Fred J. Walsh and Associates, the neoclassical revival building had more than 200 guest rooms, an expansive lobby, dining rooms, a coffee shop, a cocktail lounge, and ground-level shops. The postcard below shows the cocktail lounge in the hotel around 1940. Other businesses located in the hotel along Clinton Street were Hickey Brothers Cigar Shop and Axelson's Custom Store for Men. Munroe Brothers Real Estate Insurance Company operated out of a storefront along Scott Street. The hotel operated until 1964, when it was converted into a retirement center and nursing home. In 2003, the building was renovated and converted into apartments.

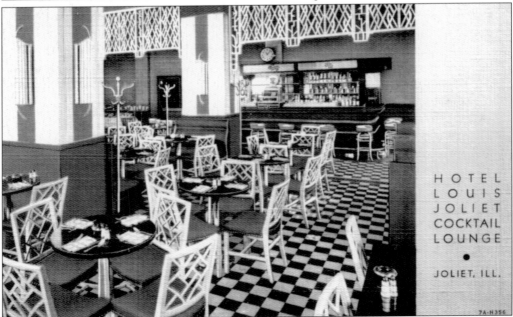

HOTEL
LOUIS
JOLIET
COCKTAIL
LOUNGE
•
JOLIET, ILL.

7A-H356

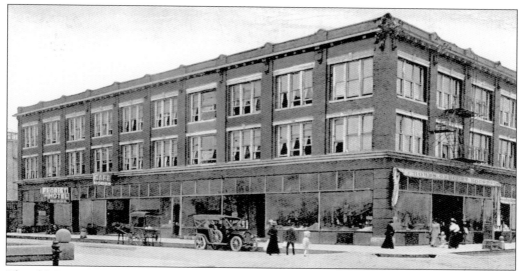

The old Ottawa Street Methodist Church occupied the southeast corner of Ottawa and Clinton Streets for many years. In 1909, the congregation sold the property to James R. Hobbs and built a new church on the northeast corner of Ottawa and Cass Streets. Hobbs soon replaced the old church with a three-story building that operated a variety of businesses over the years, including a hotel, grocery store, café, and florist shop. This postcard photograph shows the Hobbs building in the early 20th century with its familiar signs advertising the variety of businesses in the building.

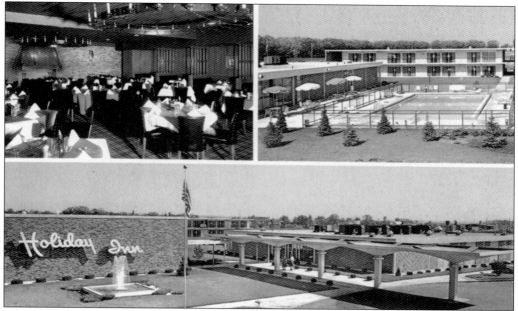

Located on Jefferson Street and old Route 66, the Holiday Inn was a favorite stop for many traveling down Route 66. This Curteichcolor postcard photograph shows the front of the hotel looking east from the parking lot, the inside of the dining room, and a look at the outside swimming pool. For many years, the Holiday Inn advertised "free TV, air-conditioning and free teletype reservations." Under new ownership, today the old Holiday Inn is now the Joliet Inn.

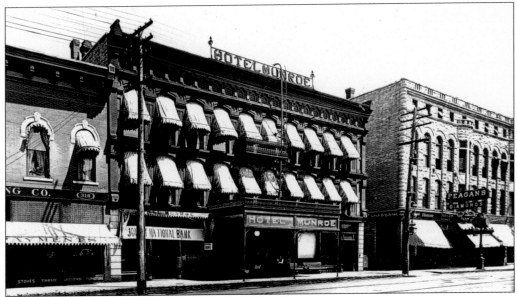

The Hotel Munroe was located on the east side of Chicago Street between Clinton and Cass Streets, just north of the auditorium building. Because of its location along Chicago Street, it was a popular place for social gatherings as well as a fine hotel for out-of-town guests. George H. Munroe and his son Edwin S. operated a real estate business and mortgage bank from a storefront on the south end of the building.

The southwest corner of Washington and Chicago Streets has been a location for hotels for many years. In 1872, Robert R. Robertson built the first hotel on this corner and the building was known as the Robertson House. This original hotel was destroyed by fire two years later and rebuilt as a four-story structure on the same site. Over the years, the ownership of the hotel changed, and in 1911, the hotel was torn down to make way for the downtown Joliet and Rock Island Railroad elevation project.

Five

PENITENTIARY AND JAIL

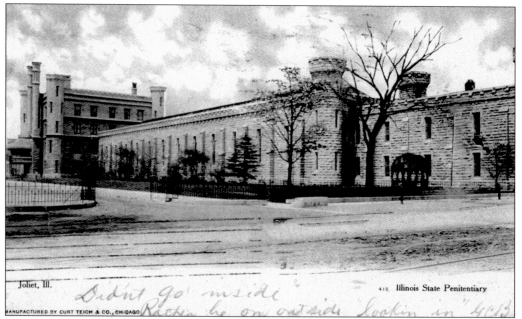

In February 1857, the general assembly authorized the building of a new state prison and appropriated $300,000 to begin the project. A 72-acre site on North Collins Street in Joliet was selected because of its transportation facilities and its abundance of limestone. Within a year, Chicago architects William Boyington and Otis Wheelock designed the new prison in an architectural style often described as castellated Gothic. Construction began on the new Illinois State Penitentiary in August 1857, and the first prisoners began arriving within five months.

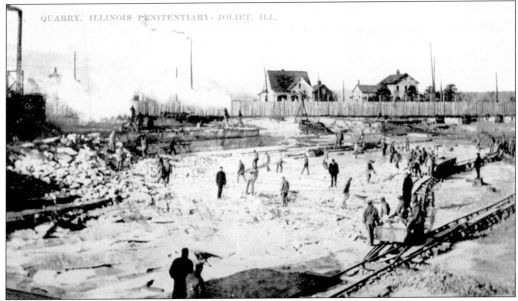

Stone quarrying in the Joliet area began during the 1830s, and limestone was used locally and regionally for a variety of structures. In 1857, the State of Illinois bought 72 areas along Collins Street for a new prison. Visiting the location in Joliet, commission members were pleased to learn that the ground around the new site was filled with limestone, which meant convicts could not tunnel out. The limestone quarry was used to build the prison walls and buildings.

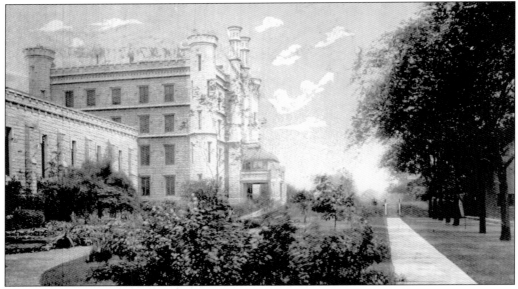

The first penitentiary in Illinois was built in 1831 at Alton near the Mississippi River. Because of overcrowding, the general assembly authorized, in February 1857, the building of a new state prison in the northern part of the state and appropriated $300,000 to begin construction. Built with convict labor, the architectural design of the new prison is described as castellated Gothic. This postcard shows the front of the Illinois State Penitentiary in Joliet. Located on Collins Street, this is the entrance to the men's prison looking east.

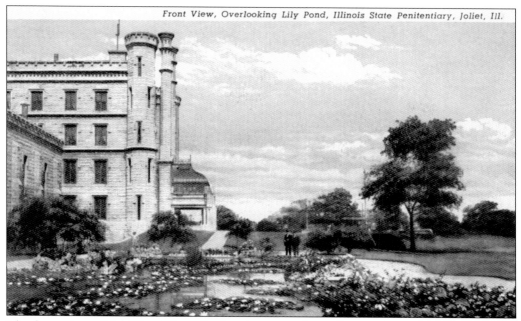

The front view of the Illinois State Penitentiary was often a favorite image for photographers. This linen-era postcard of the men's prison looking east toward Collins Street and Woodruff Road shows the front entrance of the penitentiary and the large, beautiful lily pond in the foreground. The four-story limestone administration building and the west cell house are visible on the left in this late-19th-century photograph.

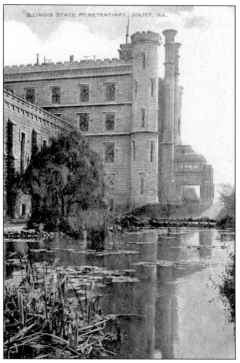

The lily pond in the foreground and front entrance of the Illinois State Penitentiary in the background are the subject of this postcard. A walkway that circled the pond took visitors in front of the west cell house and the administration building. Over the years, the area in front of the prison was changed and the lily pond was filled in. In time, a greenhouse was built just outside the west cell house, and as the area around Collins Street and Woodruff Road became congested, the landscaped lawn gave way to outbuildings and a parking lot.

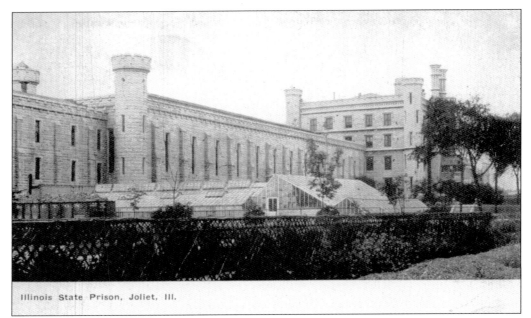

Illinois State Prison, Joliet, Ill.

Looking east from behind the fence that bordered the prison grounds, the west cell house and the main entrance in the administration building can be seen. The manicured grounds in front of the main entrance changed over the years, and the beautiful lily pond in front of the west cell house was eventually replaced by a group of greenhouses, seen in the foreground.

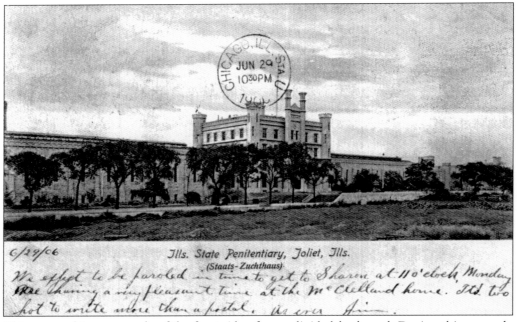

Ills. State Penitentiary, Joliet, Ills.
(Staats-Zuchthaus)

This postcard is an example of the front side of an undivided-back card. During this era, only the address could appear on the back side of the postcard, and publishers often left space on the front for the correspondence. The image on the front of this postcard is the Illinois State Penitentiary, and the card was postmarked on June 29, 1906.

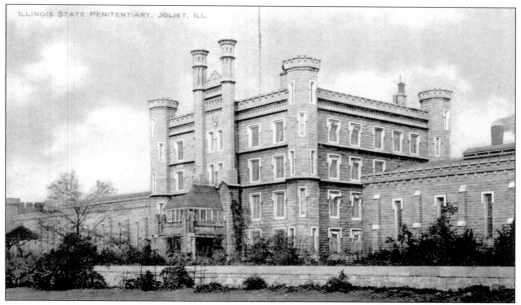

Produced by the Hammon Publishing Company in Chicago, this postcard from early in the divided-back era shows a northwestern view of the four-story administration building and main entrance. The building to the right of the administration building is the east cell house, and the long building on the left in the background is the west cell house. Each cell house had four tiers of cells and each tier had 100 cells, half facing south and the other half north.

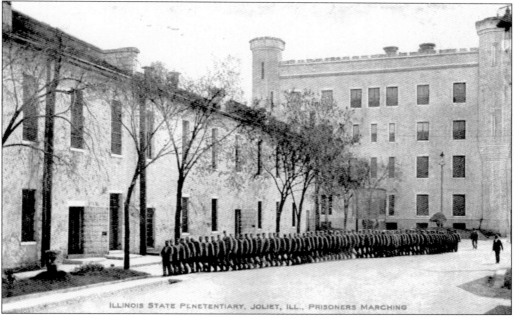

The Auburn Prison in New York became a model for prison management at the Illinois State Penitentiary. Part of this system of management and control included striped uniforms—a standard uniform until 1896—and lockstep marching on the prison grounds. The inmates were expected to remain silent, and guards with long canes kept the prisoners in check.

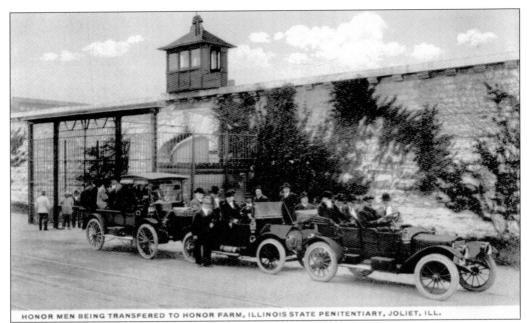

HONOR MEN BEING TRANSFERED TO HONOR FARM, ILLINOIS STATE PENITENTIARY, JOLIET, ILL.

Sally ports are guarded entry gates through the walls of the prison in which items needed to maintain and support the facility and its occupants were passed. In this postcard picture, the three automobiles are waiting to transfer honor men to the honor farm using the sally port at the Illinois State Penitentiary. An honor farm is where selected minimum security inmates are allowed greater freedom and work outside the institution doing farming and gardening work.

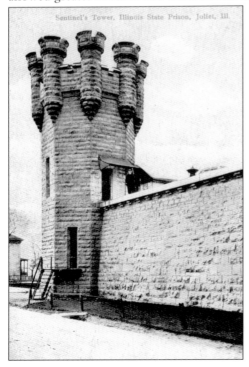

Built with Joliet limestone quarried on site, the 15-acre-square prison yard was surrounded on three sides by 25-foot stone prison walls that were six feet thick at the base and tapered to two feet wide at the top. The fourth side, facing south, was the four-story administration building. The castlelike guard towers were located at the corners of the prison yard, and officers assigned to tower duty helped to keep the prison secure.

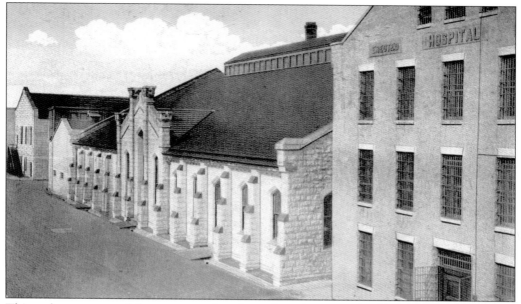

This early-era postcard shows an exterior view of two important buildings at the Illinois State Penitentiary. The building in the foreground to the right is the prison hospital, and the large building in the center is the dining hall. Built from Bedford limestone from the nearby prison quarry, the three-story hospital building was constructed in 1895. Eight years later, the large prison dining hall was erected with a tall vaulted ceiling and many exterior windows that provided plenty of light and ventilation in the room.

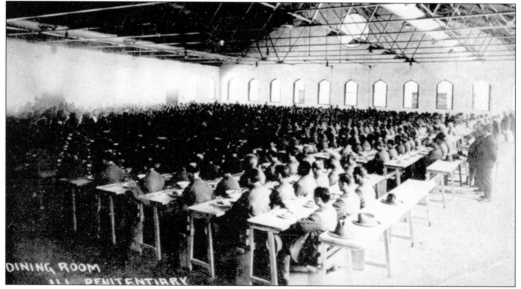

The dining hall at the Illinois State Penitentiary was built in 1903 and forever changed the manner in which meals were served at the prison. Large numbers of inmates were now fed hot meals, which required administrative discipline and rules to keep order. The rule of silence during meals was one such measure that was enforced in the hall to keep the prisoners on task. The preset rows of long tables and small benches allowed for six inmates to eat together.

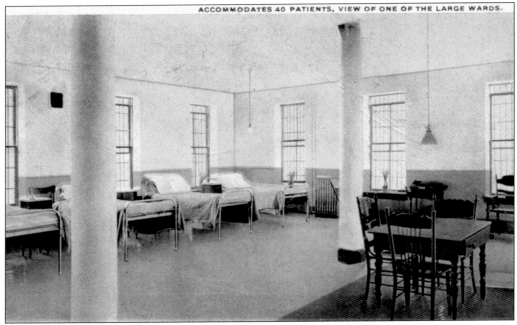

This postcard shows a view of one of the largest hospital wards—accommodating nearly 40 patients—at the Illinois State Penitentiary. Built in 1895, the new hospital provided medical care for the sick inmates at the prison. The wards provided a cleaner environment and allowed for more natural light than the regular cells. Sick prisoners confined to the hospital because of illness ate in the hospital dining room

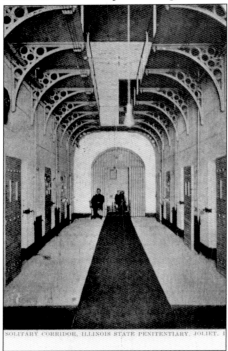

SOLITARY CORRIDOR, ILLINOIS STATE PENITENTIARY, JOLIET. I

The inmates at the Illinois State Penitentiary were punished in a variety of ways for violating the prison rules. In some instances, corporal punishment, including whipping or the wearing of leg irons, was used. Some prisoners who ended up in solitary confinement were handcuffed to a cell door for over 12 hours a day for repeated wrongdoing. This postcard shows the solitary unit at the Illinois State Penitentiary.

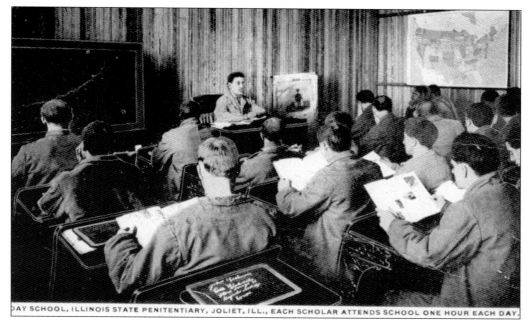

DAY SCHOOL, ILLINOIS STATE PENITENTIARY, JOLIET, ILL., EACH SCHOLAR ATTENDS SCHOOL ONE HOUR EACH DAY.

When Edward Dunne was elected governor of Illinois in 1913, he promised prison reform and fulfilled his pledge by appointing Edmund M. Allen to serve as warden at the Illinois State Penitentiary in Joliet. Once in office, Allen brought dramatic changes to the institution. One such reform was the creation of a day school program, which had an enrollment of nearly 400 students. Allen also allowed the inmates to publish their own newspaper.

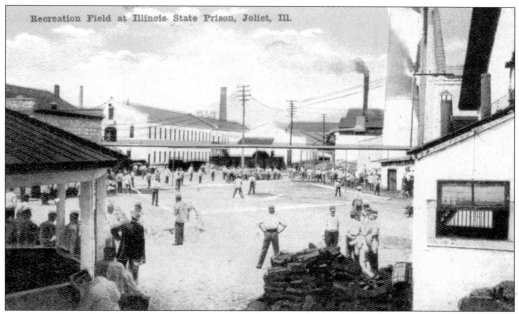

Another of warden Allen's reforms to the Illinois State Penitentiary in Joliet in the early 20th century was the decision to allow all prisoners a one-hour-per-day recreation period outside in the yard. A baseball diamond was built, and inmates enjoyed a friendly game of baseball.

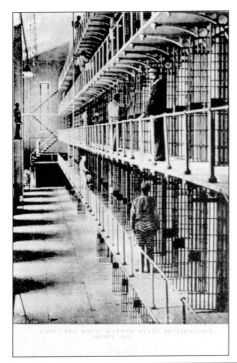

This view of the east wing of the Illinois State Penitentiary's cell house shows male prisoners being escorted to and from their open cell doors. The prison guard on the third tier and the perched guard against the exterior wall are keeping watch over the prisoners. The iron stairways at the end of the cell house wing led to the upper tiers and to the narrow galleries fronting the cells. All light, heat, and air entered the cells through the iron bars of the cell doors, each of which was equipped with multiple locking devices.

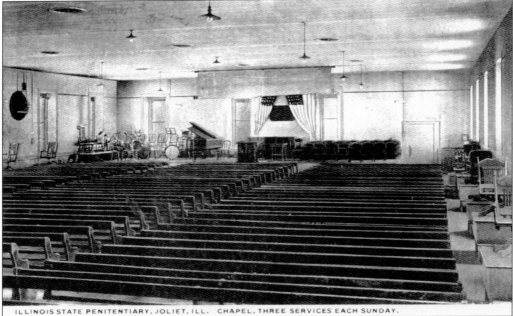

This postcard shows an interior view of the Illinois State Penitentiary chapel, where inmates gathered each Sunday for religious services. Many prisoners looked forward to Sunday, as it offered a break from their weekly routine. After Sunday morning breakfast, the prison chaplain offered three services in the chapel to accommodate the large number of attendees. The chairs behind the pulpit were reserved for the inmate choir and musical ensemble.

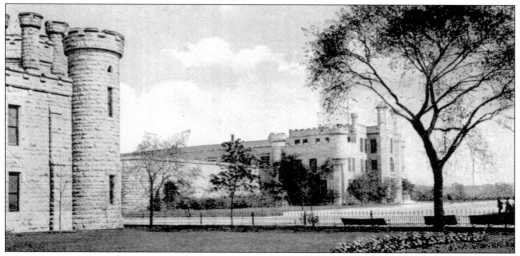

509 * Mens' and Womens'
Prisons, Joliet, Ill.
Pub. by The News Book Store.

This undivided-back postcard, published in 1904 by the News Book Store, shows a photograph of the men's penitentiary and the newly constructed women's prison in Joliet. Only the address could appear on the back side of the postcard during this era. The correspondence written on the front of the card reads, "Dear Cousin, We were pleased to hear father's coat is at your house. He did not remember where he left it and the knife also. Intended to write sooner but have been sitting round doing as I pleased . . . Lovingly, Alice."

From 1870 to 1895, female inmates at the Illinois State Penitentiary were housed on the fourth floor of the administration building. On November 25, 1896, the female prisoners left their fourth-floor residence and walked across the street to their new home. This postcard shows the administration building of the new women's prison in the distance. The architectural style of the new women's structure is very similar to the fortress design of the original penitentiary next door.

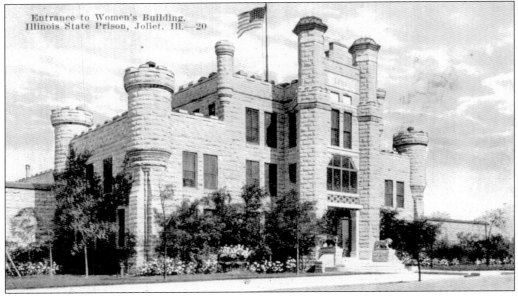

Located at the corner of Collins Street and Woodruff Road, the three-story-high women's administration building and adjoining cell house directly to the north functioned as a women's prison for nearly 34 years. In 1933, the female inmates were transferred from the women's facility on Collins Street to the new reformatory for women in Dwight. The facility was then converted into an intake and classification center for all prisoners sentenced in northern Illinois.

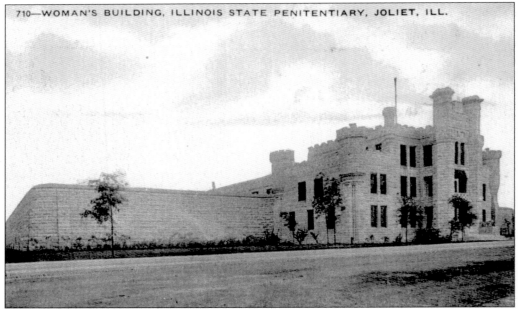

710—WOMAN'S BUILDING, ILLINOIS STATE PENITENTIARY, JOLIET, ILL.

Prison commissioners and wardens had urged lawmakers for years to build a new penitentiary for women. In 1895, the state legislature responded by appropriating $75,000 to build the new facility. The new women's prison was constructed the following year at the Illinois State Penitentiary in Joliet. This postcard photograph shows the castellated Gothic limestone structure of the women's prison. The three-story structure on the right is the administration building.

This postcard shows a first-floor workroom shop inside the new women's prison where seats of cushioned chairs were filled. The seats were designed to fit chairs manufactured in the furniture shop in the men's prison.

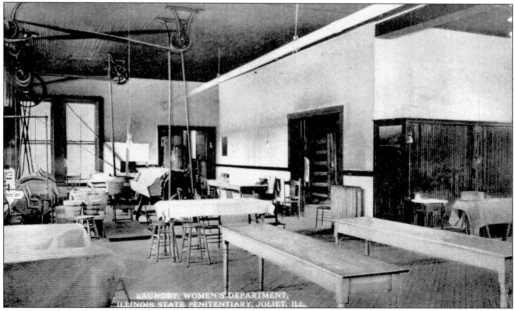

The first floor of the women's cell house included the inmates' dining room, a small chapel, a bathing room, a seat cushion shop, and the prison laundry. This postcard shows a picture of the laundry facilities at the women's prison. The prison laundry was responsible for cleaning both male and female clothing, which amounted to thousands of pieces each week. The laundry process also caused problems by allowing heat and odors to escape into other rooms of the prison, including the cell house.

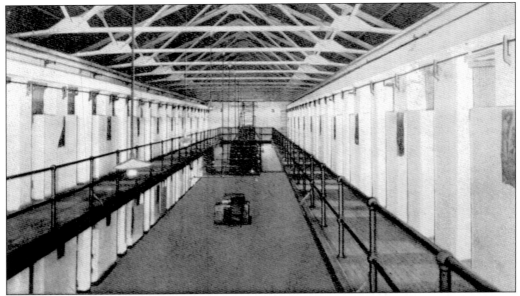

The women's cell house at the Illinois state prison was organized and built much differently from the cell houses at the men's institution. The women's cells were 8 feet wide and 10 feet long, which was twice the size of the men's cells. The cells were also built along the outside walls, which allowed for a window for natural light. Other conveniences found in the cells included a hot air duct, an exhaust fan, an electric light, and indoor plumbing.

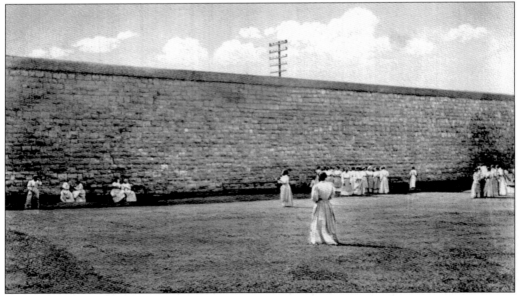

A new women's prison was constructed in 1896 across the street from the Illinois State Penitentiary in Joliet. The architectural style of the new women's structure is very similar to the design of the original men's penitentiary. The female inmates in this postcard photograph are seen playing and socializing during their outdoor recreation period. The value of physical exercise, another early prison reform measure, was viewed as important during the progressive era in the early 20th century.

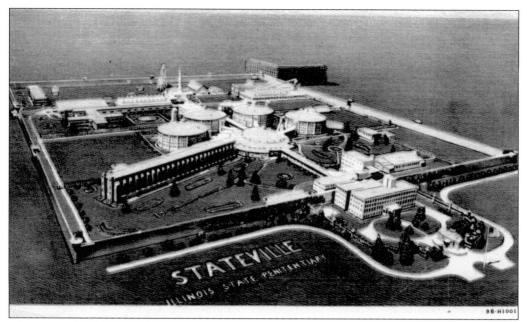

This late-1950s aerial view of Stateville prison in this linen-era postcard photograph shows a portion of the 2,220-acre penitentiary and farm property. Nearly 64 acres of the property are enclosed in the square concrete wall, 30 feet high and one and a quarter miles long. At the time of its construction in 1925, the new state penitentiary called Stateville was the largest prison yard in the United States.

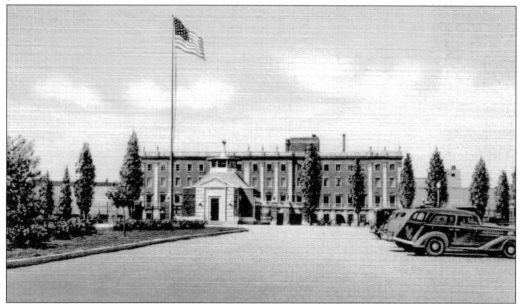

Constructed in 1931, the second-floor lobby of the administration building was the entry point for visitors to the prison. In addition to the warden's office, the administration building was also home to the warden and his family. A spacious 12-room apartment on the third floor, furnished with items made in the prison's furniture shop, was the warden's residence.

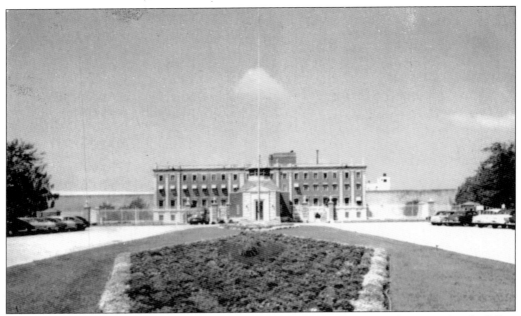

This Curt Teich photochrome-era color postcard shows the four-story administration building looking west from the landscaped parkway entrance off old Route 66. The small building in the foreground, just in front of the administration building, is the gatehouse where visitors enter and are processed before proceeding to the second floor of the administration building where the main entrance to the prison can be found.

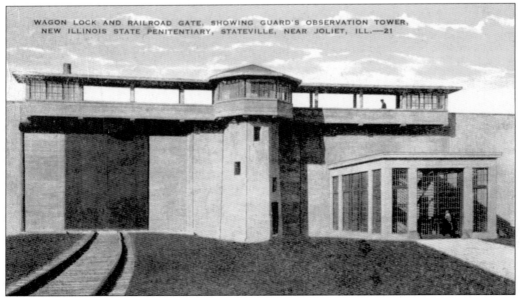

WAGON LOCK AND RAILROAD GATE, SHOWING GUARD'S OBSERVATION TOWER, NEW ILLINOIS STATE PENITENTIARY, STATEVILLE, NEAR JOLIET, ILL.—21

Sally ports are guarded entry gates through the walls of the prison through which items needed to maintain and support the facility and its occupants were passed. Food, building materials, supplies, trash, and sometimes prisoners passed into and out of the institution's grounds. In this postcard picture, the wagon lock and railroad gate of Stateville penitentiary are shown.

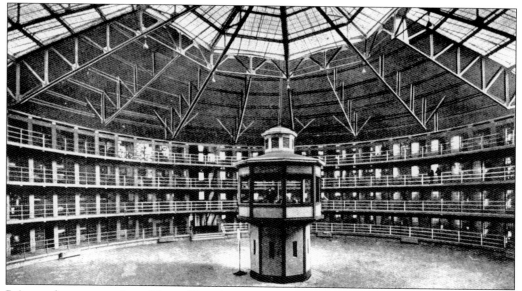

Prior to the construction of Stateville prison in 1916, a legislative committee traveled to Europe to gather information on prison design. The committee was impressed with the ideas of English philosopher Jeremy Bentham, who suggested that panopticon ("seeing all") cell houses would be practical. An officer stationed in a central tower would have a 360-degree view of the entire building. Each of the four roundhouses constructed at Stateville had four levels, with 62 cells on each tier, for a total of 248.

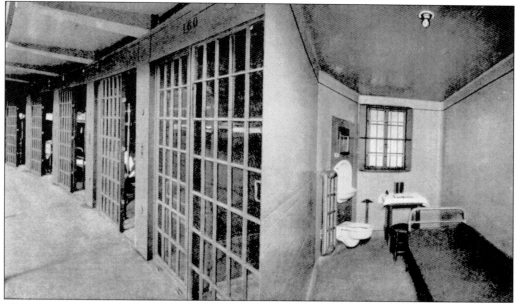

The postcard photograph on the left shows an exterior view of the reinforced glass and steel frame cell doors on each tier of the roundhouses. The photograph on the right shows an interior view of the 6-by-9-by-8-foot cells. Each cell room had an outside window, a sink, a toilet, a bed, a table and chair, heating, ventilation, and electricity. Today there is only one remaining roundhouse at Stateville.

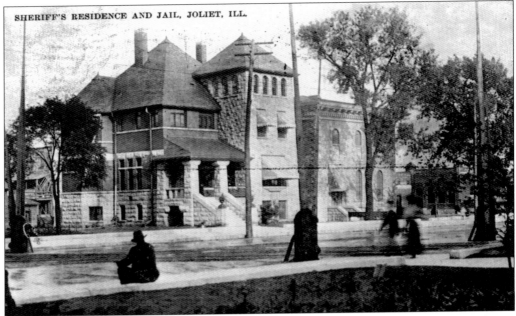

SHERIFF'S RESIDENCE AND JAIL, JOLIET, ILL.

This postcard photograph shows a view, looking east from Chicago Street and the old courthouse square, of the sheriff's residence and the Will County Jail. Records indicate that a number of executions by hanging were carried out at the old jail during the 19th and early 20th century. When the sheriff's residence and jail were torn down in 1969, Chicago Street was closed to traffic, and a new parking lot was created just east of the new courthouse.

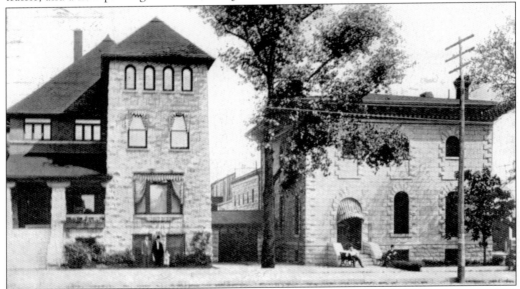

This divided-back postcard shows a photograph of the old Will County Jail and the sheriff's residence. Located near the old courthouse on the northeast corner of Chicago and Washington Streets, the Will County Jail is the two-story limestone building on the right, and the sheriff's home is the structure on the left. When the new courthouse was completed in 1969, the sheriff's house and jail were razed to create the courthouse and public parking lot.

Six

Fire, Flood, and Canal

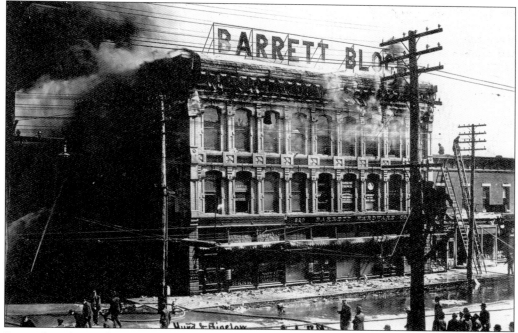

Located on the southeast corner of Chicago and Clinton Streets, the three-story Edwin S. Munroe building was commonly known as the Barrett Block because the hardware company leased space in the building. Built in 1883 with Joliet limestone, the building also housed the Joliet National Bank and rented space to tenants on the upper floors. Just before noon, on Saturday, April 4, 1908, a fire broke out in the hardware store, and within minutes, the entire building was in flames. The cause of the fire is still a mystery.

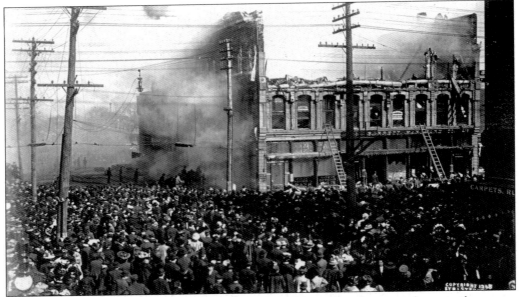

This divided-back postcard shows the estimated 10,000 people who came down to the corner of Chicago and Clinton Streets to watch the Joliet firemen battle the Barrett Hardware fire. Combustible materials in the hardware store helped the fire spread so rapidly through the building. This photograph shows the third-floor facade and roof missing from the building. Newspaper accounts from the day place the loss at over $150,000.

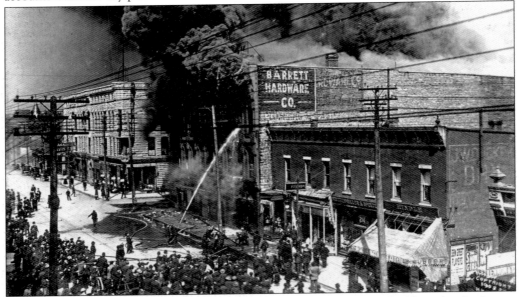

Looking north on Chicago Street, Joliet firefighters are working on the blaze that broke out shortly before noon on April 4, 1908, at the Edward S. Munroe building. While the fire still remains a mystery, it is known to have started in the basement of the Barrett Hardware Company and spread rapidly throughout the building. The photograph shows the southerly winds helping to fan the flames and carry embers to nearby buildings, including the auditorium building across the street.

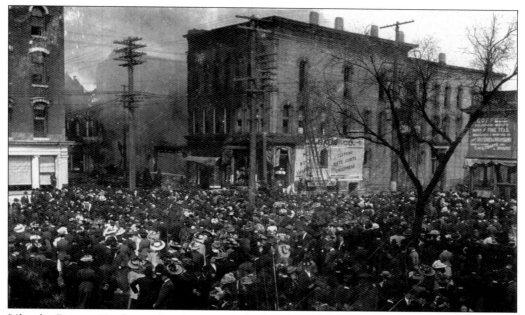

Like the Barrett Hardware fire three weeks before, thousands of people gathered in the streets around the Boston Store on the morning of April 26, 1908, to watch the firemen work to try to save the store and the adjoining buildings. The total damages were estimated to be over $300,000. The Boston Store eventually purchased the Spot Cash corner building across the street and built a new five-story building.

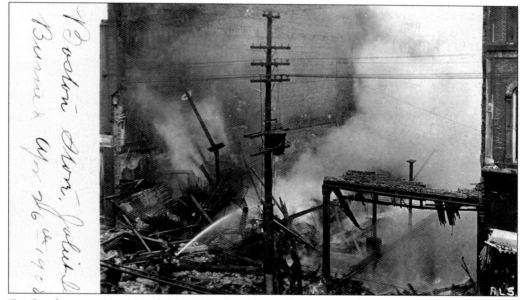

On Sunday morning, April 26, 1908, the Boston Store, located on the northwest corner of Jefferson and Ottawa Streets, was totally destroyed by fire. The Boston Store, Joliet's largest department store, caught fire at 6:00 in the morning when a fire broke out on the second floor of the building. This postcard photograph shows the aftermath of the fire. The written note on the left side reads, "Boston Store, Joliet, Illinois, burned April 26, 1908."

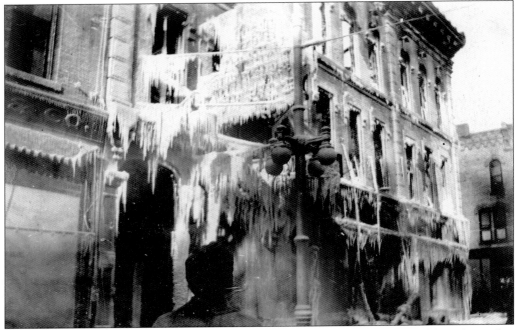

Early in the morning on January 24, 1915, a fire broke out in the D'Arcy Building, located at the southwest corner of Van Buren and Chicago Streets. The Crystal Stairs Theatre was located on the second floor of the building. Nearly 500 spectators braved the subzero temperature and watched as firefighters tried to battle the flames. Because of the temperatures, large icicles began to form on the exterior of the building as the firemen poured water onto the blaze.

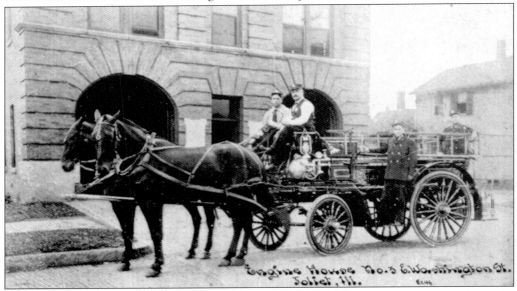

The Joliet Fire Department began as a volunteer bucket brigade in 1849. Four years later, the department was officially organized. By 1877, the city had created and funded a full-time fire organization and appointed J. D. Paige as the city's first fire marshal. His salary was $200 a year. This postcard shows a picture of Engine House No. 3 on East Washington Street in Joliet.

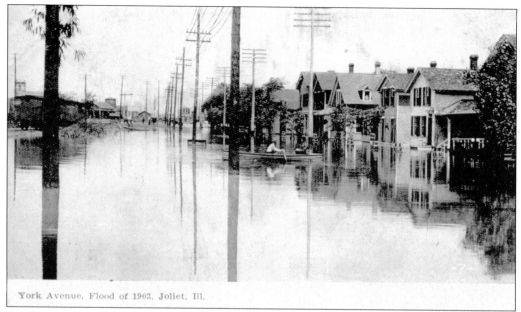

York Avenue, Flood of 1903, Joliet, Ill.

On the evening of June 2, 1902, the east side of Joliet was hit by a cloudburst that dumped over four inches of rain and claimed three lives. The low areas near Hickory and Spring Creeks were especially hard-hit. Miles of railroad tracks were washed out, bridges were swept away, homes and businesses were flooded, and livestock was drowned. The estimated property damage to railways and industry was near $500,000, and the value of household goods destroyed was over $50,000.

Located just east of South Chicago Street on Joliet's near east side, York Avenue was one of the areas hit hard after the early summer flood of 1902. The waterways around Joliet, including Hickory and Spring Creeks, could not handle the 4.03 inches of rainfall on June 2, 1902. The area near Jefferson Street and Eastern Avenue, near York Avenue, was one of the most severely damaged. At least 100 families were rendered temporarily homeless. The damage to walks and streets was estimated at nearly $10,000.

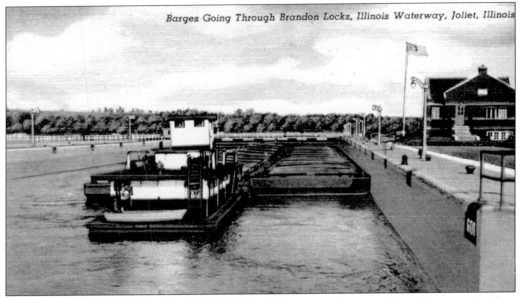

Barges Going Through Brandon Locks, Illinois Waterway, Joliet, Illinois

The Brandon Road Lock and Dam, also known as the Brandon Road Pool, is a gravity dam located on the Des Plaines River about three miles south of Joliet. Used to improve navigation, the lock and dam was open in 1933, modified in 1985, and is owned by the U.S. Army Corps of Engineers. The lock is at mile 286 on the Illinois Waterway and is 110 feet wide and 600 feet long, with a lift of 31 feet.

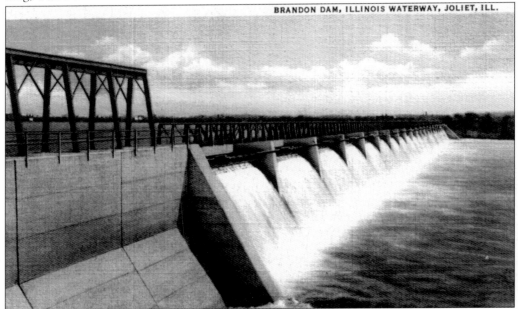

BRANDON DAM, ILLINOIS WATERWAY, JOLIET, ILL.

This Curt Teich linen-era postcard shows the Brandon Dam on the Des Plaines River, just south of Joliet near Rockdale. On the Illinois Waterway, eight dams hold back water to form eight pools very similar to long narrow lakes. These dams raise the water level enough to accommodate the large tows that require nine feet of water to operate. This arrangement creates a "stairway of water" that drops 163 feet from Lake Michigan to the Mississippi River.

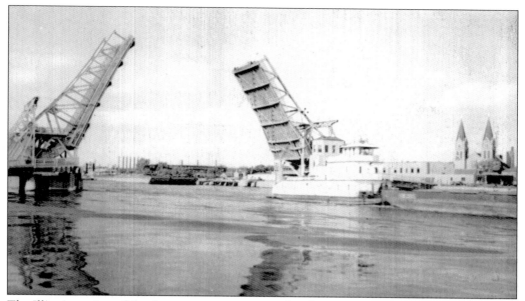

The Illinois section of the deep waterway was completed in 1933, and its construction through Joliet is an outstanding hydraulic engineering accomplishment. This Curt Teich photochrome-era postcard scene of the Des Plaines River looking north shows a towboat passing the Jackson Street bridge. The twin church spires of the historic 1891 St. Joseph Church and the smokestacks of the Illinois Steel Company can be seen on the east side of the river.

The Illinois and Michigan Canal was constructed in 1848. Nearly 100 miles long, it ran from Chicago to La Salle. Joliet was an important canal town along the route. Mailed on November 13, 1907, the correspondence on the back of this card reads, "Dear sister, How are you this day? I am washing, baking bread and pies etc. The little chicks are growing fine, will soon be large enough for quail on toast but, hardly large enough to roast already—Mrs. Mike K."

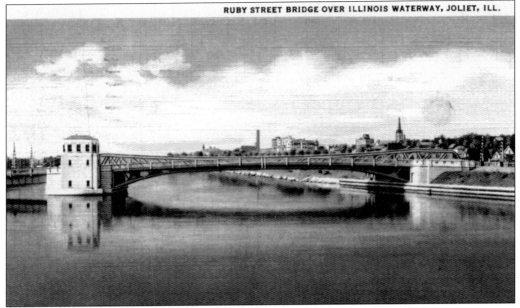

From McDonough Street on the south to Ruby Street on the north, Joliet has six lift bridges that span across the Des Plaines River. The modern Scherzer rolling lift bridges are found at McDonough, Jefferson, Cass, and Jackson Streets. The Ruby Street bridge is a bascule trunnion–style bridge. The Joliet Railroad bridge is a vertical lift (truss) bridge.

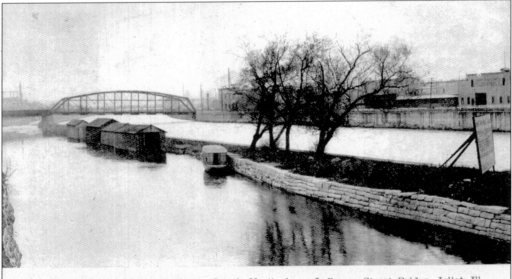

Old I. & M. Canal—Chicago Drainage Canal, North from Jefferson Street Bridge, Joliet, Ill.

This divided-back postcard photograph shows the Illinois and Michigan Canal in the foreground and the drainage canal (Des Plaines River) in the background. This photograph is looking north from the Jefferson Street bridge. The Illinois and Michigan Canal and locks were located along the west bank of the Des Plaines River. Lock 5 was near the Jackson Street bridge. The old towpath seen in the foreground was submerged in the early 1930s to make room for the new Illinois Waterway.

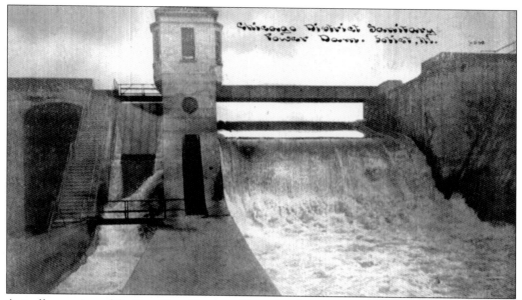

A smaller version of the Bear Trap Dam was located at the sanitary district power station, located a mile south of the controlling works. The Bear Trap Dam controlled the flow of water to the power station. Taking advantage of the 40-foot drop in elevation from Lockport to Joliet, the power plant was able to develop 40,000 horsepower and supplied Lockport manufacturers with cheap power. This picture, looking north, shows the dam and the power plant on the left.

The sanitary district power station was located one mile south of the controlling gates. The sanitary canal powerhouse was used to generate power by using water from the canal to drive turbines, which generated 40,000 horsepower of electrical power. A hydroelectric marvel, the powerhouse is still hard at work after 100 years of harnessing the power of the canal in Lockport. The Lockport powerhouse is recognized as the oldest hydroelectric project in Illinois.

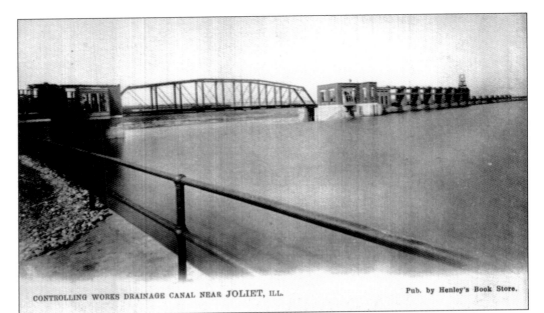

CONTROLLING WORKS DRAINAGE CANAL NEAR JOLIET, ILL.

Pub. by Henley's Book Store.

This divided-back postcard shows another view of the controlling works and drainage canal looking south near Joliet. The iron bridge on the left is directly over the Bear Trap Dam, which helps to control the flow of water from the sanitary canal into the Des Plaines River watershed. The structures on the right are the waste gates, designed to control the level of the drainage canal. The canal opened in 1900 and runs from Chicago to Lockport.

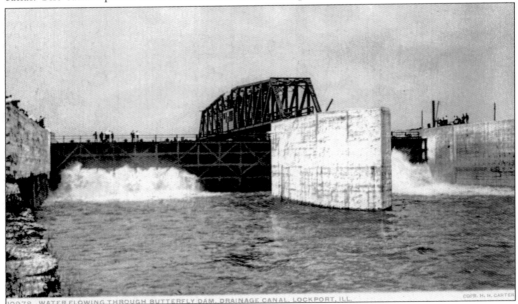

WATER FLOWING THROUGH BUTTERFLY DAM, DRAINAGE CANAL, LOCKPORT, ILL.

The Butterfly Dam at Lockport marked the end of the 28-mile Chicago Drainage Canal. The control of the water flow from the drainage canal into the Des Plaines River was not at the mouth of the Chicago River but at the terminus of the canal in Lockport. This postcard photograph shows the Butterfly Dam, which could be closed if there was a sudden rush of water from Chicago.

Seven

PARKS, STATUES, PARADES, AND MISCELLANEOUS

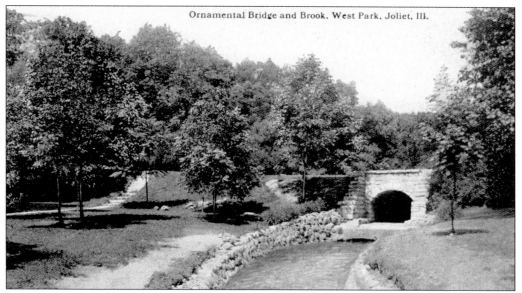

Ornamental Bridge and Brook, West Park, Joliet, Ill.

Visitors to West Park enjoyed the footpaths and roads that meandered throughout the scenic 40 acres just south of Joliet. The steep ravines and wooded rolling terrain offered the large crowds that patronized the park a wonderful backdrop for the changing seasons. This postcard photograph shows the ornamental arched bridge and rock-scaped brook that flowed through the south side of the park.

Joliet, Ill. *A nice place for a Christmas tree.* 413. West Park.

To the south of Joliet, near Rockdale, is Bush Park, or what is now known as West Park. For many Joliet residents, this beautiful park was known as a wonderful place to picnic and enjoy the many long, winding roads and footpaths. Besides the rustic bridges and springhouse, the park was a great place to see the changing seasons, play baseball, dance in the pavilion, or attend a concert at the open-air theater.

West Park, formerly known as Bush Park, located south of Joliet near Rockdale, once contained three separate playground areas, softball diamonds, a dance pavilion, tennis courts, an open-air theater, a football field, and several picnic areas. On the south side of the park, there was an artificial pond, which in the winter months was used for ice-skating, and a shallow brook that meandered through the park. The West Park pavilion, footbridge, and springhouse can be seen in this scenic postcard photograph.

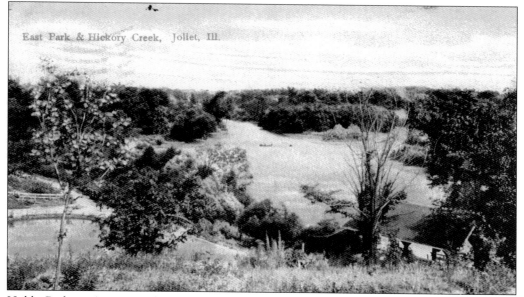

Hobbs Parkway is a scenic driveway link between Highland Park and Pilcher Park. In the early years of the Joliet Park District, visitors to the parks called the area east of Hobbs Parkway East Park. This postcard photograph shows a view of East Park (Pilcher Park) that was a favorite location for many because of the picturesque view of Hickory Creek from the boathouse. In the winter months, visitors to the park would enjoy ice-skating on the lake.

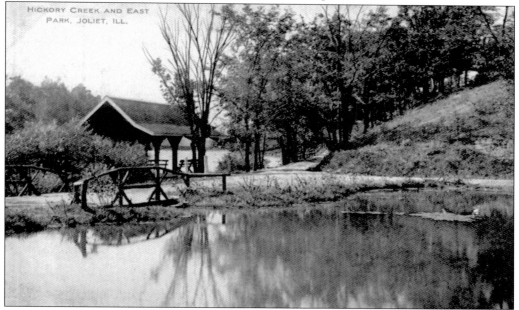

East Park (Pilcher Park) is located east of downtown Joliet on Gougar Road. In 1920, Robert Pilcher donated over 300 acres to the City of Joliet with the stipulation that the land be left in its wild and natural state. The Joliet Park District was organized in July 1922 to tend to the needs of the parks and the facilities. This postcard shows a view of the boathouse located on Hickory Creek.

A few miles east of downtown Joliet, residents are able to enjoy a variety of outdoor activities at Highland Park, Pilcher Park, and Higginbotham Woods. Boating, fishing, swimming, golfing, horseback riding, dancing, baseball, tennis, or walking the woodland pathways are just a few of the popular activities enjoyed by willing participants. This postcard shows a panoramic view of Highland Park from the observation tower near the baseball field.

Highland Park was one of the first parks in the Joliet Park District system. Located east of downtown Joliet on Cass Street, the park provided visitors throughout the years with such amenities as tennis courts, a dance pavilion, and boating, swimming, ice-skating, and picnic areas. A large log cabin, pictured here, was located in the far northwest corner of the park, near the baseball diamonds, and was used by various organizations, including the Boy Scouts, for meetings and gatherings.

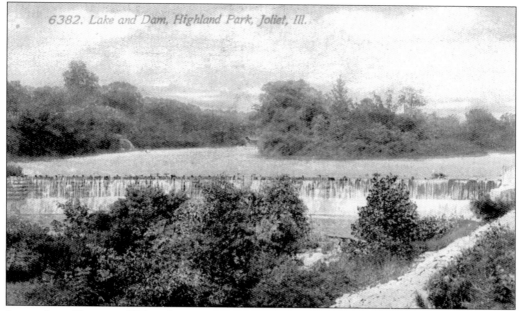

Located on 60 acres off East Cass Street on Joliet's east side, Highland Park is one of the first parks in the Joliet Park District system. At one time, the beautifully landscaped park contained a large picnic area, tennis courts, a dance pavilion, and baseball and softball diamonds. The postcard photograph shows the large lake and dam at the park.

The Bird Haven Greenhouse and Conservatory sits on three acres of land within a 660-acre site, comprised of Pilcher Park and Higginbotham Woods. The greenhouse and conservatory was constructed in the early 1900s. This Italian Renaissance–style facility, designed by the Lord and Burnham Company, features spectacular floral shows with seasonal motifs during the fall, winter, and spring. This postcard photograph shows a view of the greenhouse looking west from Gougar Road.

Pilcher Park is perhaps the most popular local park in Will County for nature lovers. Robert Pilcher, a self-taught naturalist and businessman, donated the original 327 acres to the City of Joliet in 1920, with the stipulation that the land be left in its wild and natural state. This postcard shows a view of the flower gardens near the greenhouse and conservatory.

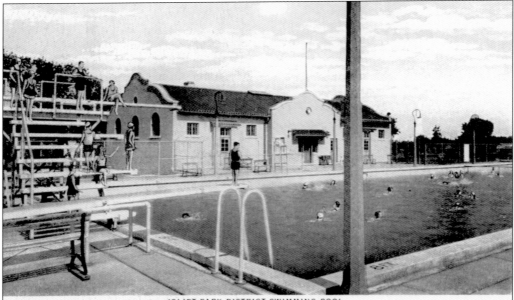

JOLIET PARK DISTRICT SWIMMING POOL

Located on the corner of Mills Road and Route 53, the Nowell Park pool was built in 1929 and provided east side Joliet residents with a place to cool off and swim during the hot midwestern summers. In 2005, the 76-year-old outdoor pool was closed by the Joliet Park District due to low attendance. The swimming pool was closed once before for nearly 20 years but reopened to the public in 1980. This postcard shows a view of the pool and the pool house.

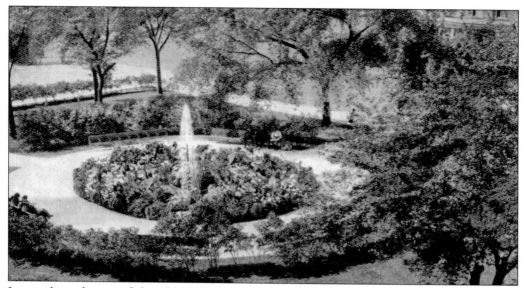

Located southwest of the old Will County Courthouse, near the corner of Ottawa and Washington Streets, was a small park in the courthouse square. The small park offered downtown visitors a place to spend part of their lunch relaxing on the park benches or walking through the beautifully landscaped courthouse grounds. This postcard photograph shows the pond, fountain, and flower beds in the park. When the old courthouse was razed in 1969 and the new facility was built, the park was lost.

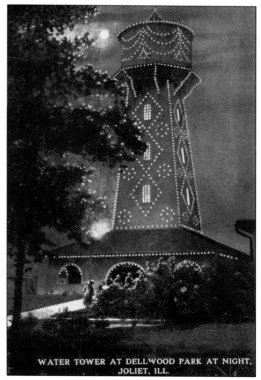

A boathouse, a boating course on the lake, a dance hall, a merry-go-round, an open-air theater, and a restaurant are just a few of the many attractions that made Dellwood Park a popular destination in the early 20th century for thousands of annual visitors from Chicago and the Joliet area. This postcard photograph shows the water tower and confectionary stand at the park illuminated at night, which created a perfect atmosphere for those who enjoyed a quiet stroll in the evening.

WATER TOWER AT DELLWOOD PARK AT NIGHT, JOLIET, ILL.

This divided back–era postcard shows a photograph of a group of children playing in the sand and enjoying their day at Dellwood Park near Joliet. Mailed on September 8, 1911, the correspondence on the back side reads, "Dear Belle, Am sending Annie a card so will send you one also. Aggie got home Sunday night about seven-thirty. They had a most delightful time but of coarse to short. Everyone is just fine down there and they have a nice place. Mother likes it she will be gone a month."

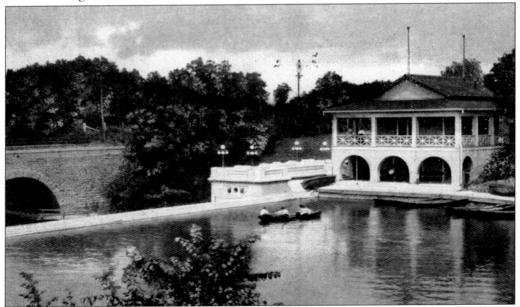

This postcard photograph shows a view of the Dellwood Park boathouse, boating course, and dam. The arched railroad bridge to the left is part of the interurban railway and local streetcar tracks, which brought visitors to the park each day. The decorative globe lights on the landing in the center allowed visitors to see their way at night as they descended the stairway to the bottom of the dam. The boathouse on the right burned down in the 1930s.

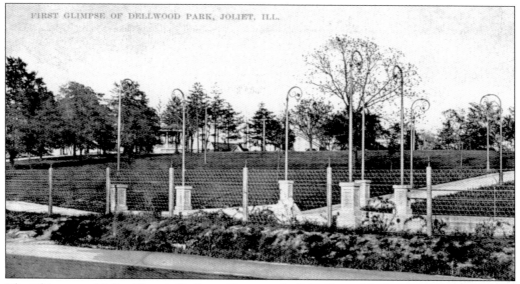

The Chicago and Joliet Electric Railway Company built Dellwood Park in 1906 to increase the number of railway riders. Located north of Joliet in Lockport, the park included a boathouse, a dance hall, a grandstand for races, a merry-go-round, an open-air theater, a restaurant, and other attractions that made the park a popular spot for thousands of annual visitors from all over the area. This postcard photograph shows the first glimpse of Dellwood Park when arriving by train.

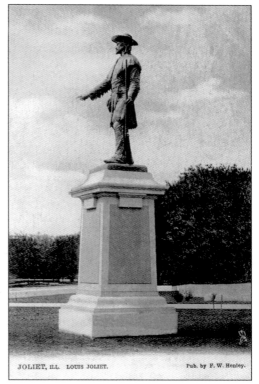

French explorer Louis Jolliet lead an expedition from Canada into the Mississippi Valley in 1673 in search of the Gulf of Mexico. Although he never reached the gulf, it was his return trip that brought him through this region. Using the Illinois and Des Plaines Rivers to get back to Lake Michigan, Jolliet traveled passed a large mound on the river near Joliet, which he named. This statute to the French explorer is in front of the Joliet Public Library.

JOLIET, ILL. LOUIS JOLIET. Pub. by F. W. Henley.

117

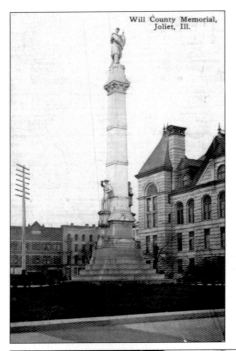

Will County Memorial, Joliet, Ill.

In 1889, the Will County Board decided to erect a monument honoring its soldiers and sailors in the new courthouse square. Located for many years near the third Will County Courthouse on Chicago Street, the 50-foot monument had the figure of Col. Frederick Bartleson, considered by many to be the first in Will County to volunteer for the Union army in the Civil War. When the fourth Will County Courthouse was built in 1969, the monument was moved to its present location in front of the main entrance.

Looking east from the corner of Jefferson and Ottawa Streets, this postcard photograph shows the third Will County Courthouse decorated for the June 13–15, 1911, veterans' celebration. Veterans from the Grand Army of the Republic commemorated the 50th anniversary of the beginning of the Civil War with a parade during their 45th annual encampment in Joliet. The advertising sign on the utility post in front of the Spot Cash store reads, "Fizz, Bang, Boom in Joliet on July 4th."

In 1910, the Coliseum Theatre was built on the southeast corner of Chicago and Webster Streets. A year later, the building was decorated with flags and banners for the 45th annual Grand Army of the Republic encampment in Joliet in June 1911. To help commemorate the event, veterans from the Grand Army of the Republic helped to remember the 50th anniversary of the start of the Civil War with parades and picnics.

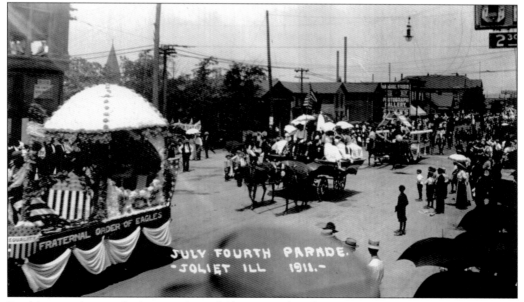

Looking north near the intersection of Chicago and Webster Streets, Joliet residents brave the warm weather and turn out to view the 1911 Fourth of July parade. Umbrellas shade the sun as the parade passes in front of the Orpheum Theatre. The Fraternal Order of Eagles float on the left is headed south on Chicago Street. Small American flags help celebrate the patriotic mood of the day as veterans from the Civil War participated in the event.

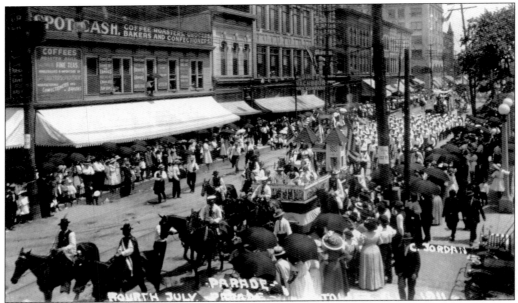

Joliet area residents line both sides of Jefferson Street to see the July 4, 1911, parade down the streets of the city. Looking east from the corner of Ottawa and Jefferson Streets, citizens enjoyed the view as horse-drawn floats, bands, civic groups, political organizations, and veterans march in the parade.

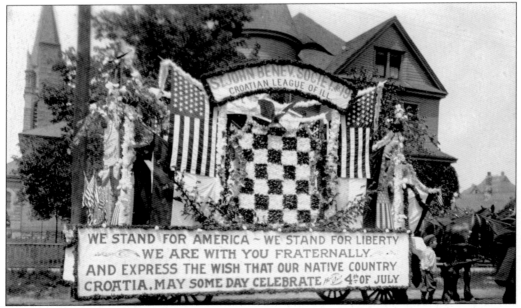

Everyone loves a parade, and Joliet residents are no exception. This postcard shows a float constructed by the St. John Benevolent Society and the Croatian League of Illinois. Using the spirit of the national holiday, the group makes the following political statement on the float: "We Stand for America—We Stand for Liberty, We are with you fraternally and express the wish that our native country Croatia, may some day celebrate her own 4th of July."

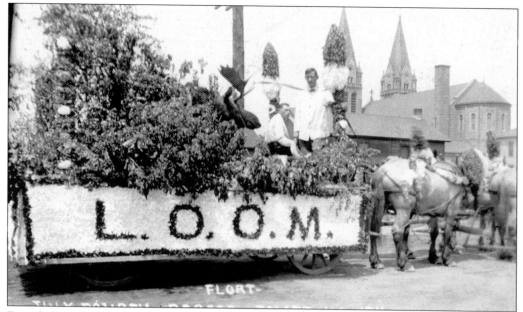

Founded in 1888, the Loyal Order of Moose is a fraternal and service organization. This postcard photograph shows the Loyal Order of Moose float lined up near the corner of Scott and Jackson Streets for the 1911 Fourth of July parade. The rear of St. Joseph Church on North Chicago Street, with its 152-foot-high twin spires, can be seen on the right.

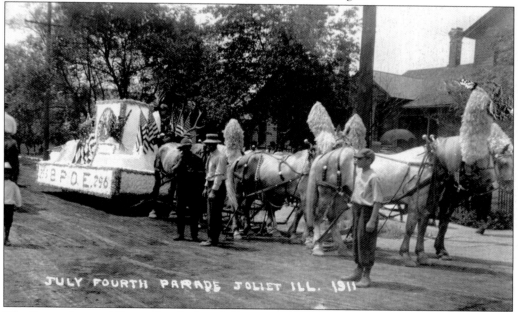

The Benevolent and Protective Order of Elks was founded in 1868 in New York as a drinking club by a group of actors in an informal drinking society called the Jolly Corks. The name of the new organization was selected because the elk has a number of attributes that were deemed typical of those to be cultivated by members of the fraternity. The Elks float pictured in the postcard photograph was part of the July 4, 1911, parade in Joliet.

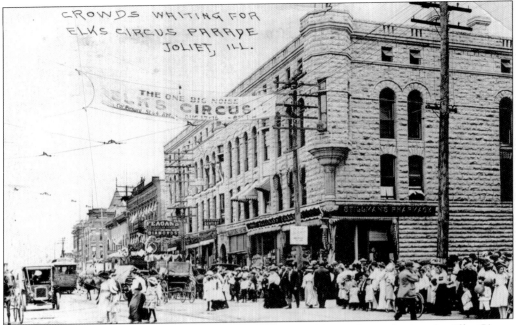

These 1909 postcard photographs are looking north on Chicago Street during the Elks Circus parade in downtown Joliet. The photograph above was taken from the Clinton Street intersection and shows the crowds waiting for the Elks Circus parade to pass by. The building on the right is the auditorium building with the familiar Stillman's Pharmacy on the corner. The large banner above Chicago Street announces, "The One Big Noise—Elks Circus—cor. Richard St. & 4th Ave. Aug. 17 & 18, 8:00 P.M." The photograph below was taken one block south, near the Van Buren Street intersection.

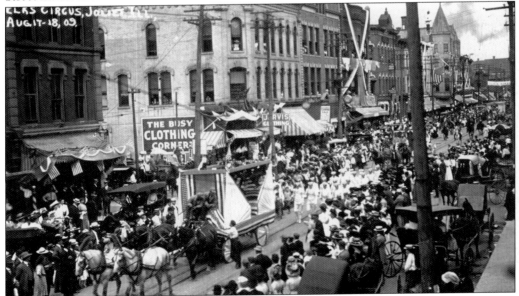

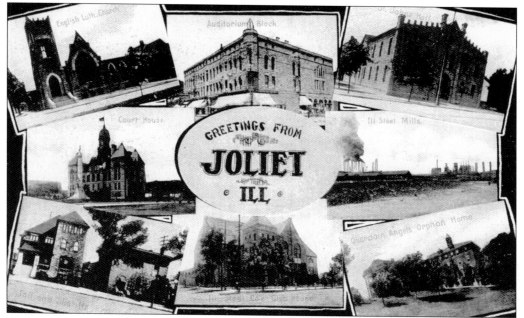

This divided back–era postcard titled "Greetings from Joliet" shows eight landmark photographs from around the city of Joliet. These photographs include, clockwise from top left, St. John's English Lutheran Church, the auditorium building, St. John's Hall, the Illinois Steel Company complex, the Guardian Angle Home, the Steel Works Club, the sheriff's home and jail, and the third Will County Courthouse.

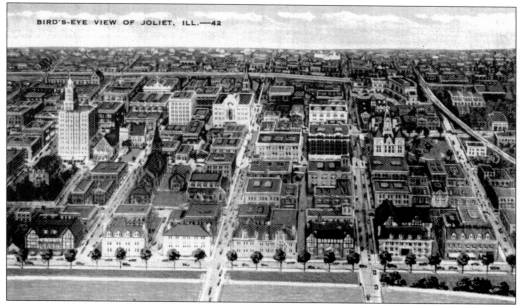

This postcard represents a bird's-eye view of downtown Joliet looking east from the Des Plains River. Downtown landmarks can be seen in this artistic portrait of the city, including the union station, the third Will County Courthouse, the elevated railroad tracks, the Woodruff Hotel, the public library, Christ Episcopal Church, and the Boston Store.

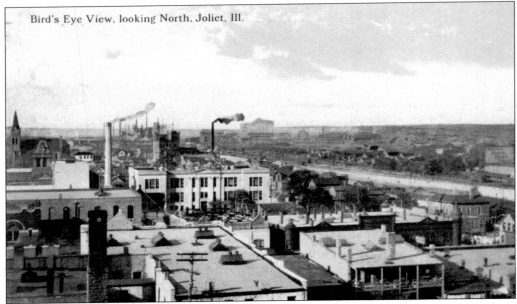

Bird's Eye View, looking North, Joliet, Ill.

This postcard represents a bird's-eye view of downtown Joliet looking north. Familiar downtown landmarks such as Center School, St. Joseph Church, the elevated railroad tracks, and the Joliet steel mills can be seen from this rooftop photograph. Mailed in 1938, the correspondence on the back reads, "Dear Sister, Glen was here late this P.M., Audrey has a bad soar throat, not S. T., as they thought though. Will let you know more in a day or so as I know you love this little girl of ours . . . With Love L.J."

This bird's-eye view of downtown Joliet looking east was taken from the west side of the Des Plaines River near the Cass Street bridge. The Joliet Public Library is located on the left in the picture and the tall 200-foot spire of St. Mary's Carmelite Catholic Church on the northwest corner of Ottawa and Van Buren Streets can be seen in the center of the photograph. In the distance, the third Will County Courthouse is visible.

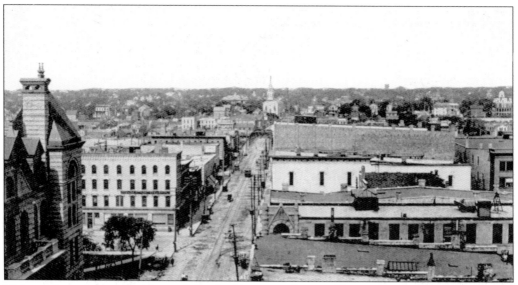

This rooftop view of downtown Joliet looking west down Jefferson Street was taken from the top of the new Woodruff Building, located at the corner of Jefferson and Chicago Streets and constructed in 1910. On the left is the third Will County Courthouse, and across the street on the southwest corner of Ottawa and Jefferson Streets is the four-story Will County National Bank. In the distance, St. Patrick's Catholic Church and the Hiram B. Scutt Mansion on Broadway Street can be seen.

This linen-era "Greetings from Joliet Illinois" postcard shows eight different photographs from around the state of Illinois. Located inside the letters of the word *Illinois* are landmark images from around the state, including Abraham Lincoln's tomb, Lincoln's home, Starved Rock State Park, and the capitol building in Springfield. The postcard was mailed in Joliet on November 11, 1942, and the correspondence reads, "Dear Sis, Spending the day in Joliet with friends. Write us."

BIBLIOGRAPHY

Come to Joliet: Illustrating and Describing the Industrial, Commercial and Residential Advantages of Joliet, Illinois. Joliet: Joliet Business Men's Association, 1900.

Genealogical and Biographical Record of Will County, Illinois. Chicago: Biographical Publishing Company, 1900.

Greene, William R. "Early Development of the Illinois State Penitentiary System."

"Joliet in Photos." *Joliet News*, 1909.

Journal of the Illinois State Historical Society 70 (1977): 185–195.

Lamb, John M. "Early Days on the I&M Canal." *Chicago History* 3 (Winter 1974–1975): 168–170.

Sterling, Robert E. *Joliet: A Pictorial History*. St. Louis: G. Bradley Publishing, 1986.

———. *Joliet Junior College 1901 to 2001: A Pictorial History of America's Oldest Public Community College*. St. Louis: G. Bradley Publishing, 2001.

———. *Joliet Prisons: Images in Time*. G. Bradley Publishing, 2003.

———. *Joliet, Then and Now*. St. Louis: G. Bradley Publishing, 2004.

———. *Joliet: Transportation and Industry, A Pictorial History*. St. Louis: G. Bradley Publishing, 1997.

———. *A Pictorial History of Will County*. 2 vols. Joliet: Will County Historical Publications Company, 1975–1976.

Woodruff, George H. *Fifteen Years Ago: or the Patriotism of Will County*. Joliet: James Goodspeed, 1876.

———. *Forty Years Ago! A Contribution to the Early History of Joliet and Will County*. Joliet: Joliet Republican Stream Printing House, 1874.

———. *The History of Will County, Illinois*. Chicago: William Le Baron Jr. and Company, 1878. Reprint, Joliet: Will County Bicentennial Committee, 1973.

INDEX

ACROSS AMERICA, PEOPLE ARE DISCOVERING SOMETHING WONDERFUL. *THEIR HERITAGE.*

Arcadia Publishing is the leading local history publisher in the United States. With more than 3,000 titles in print and hundreds of new titles released every year, Arcadia has extensive specialized experience chronicling the history of communities and celebrating America's hidden stories, bringing to life the people, places, and events from the past. To discover the history of other communities across the nation, please visit:

www.arcadiapublishing.com

Customized search tools allow you to find regional history books about the town where you grew up, the cities where your friends and family live, the town where your parents met, or even that retirement spot you've been dreaming about.